IMAGES
of America

HOT RODDING IN SANTA BARBARA COUNTY

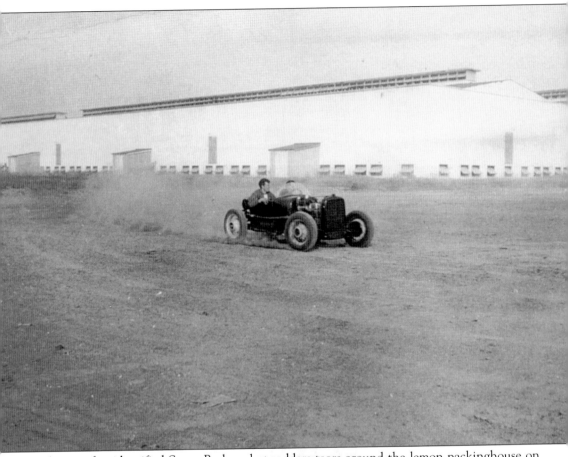

A pair of unidentified Santa Barbara hot-rodders tears around the lemon packinghouse on Salsipuedes Street sometime in 1941. This scene evokes a different time in Santa Barbara, when there were still large unpaved areas in places that are now unrecognizably developed. The packinghouse is still there, although altered and no longer used for lemons. It can still be seen today as one passes by on Highway 101. (Courtesy of Jack Chard.)

ON THE COVER: A Ford Model A hot rod crosses the finish line at Goleta Drag Strip in 1948. The chopped 1931 Tudor has had the rear windows blanked out, and a sprint car–type radiator shell has been added. In the background is the wetlands area known as the Goleta Slough. (Courtesy of Lee Hammock.)

IMAGES
of America

HOT RODDING IN SANTA BARBARA COUNTY

Tony Baker

ARCADIA
PUBLISHING

Published by Arcadia Publishing
Charleston, South Carolina

Printed in the United States of America

Library of Congress Control Number: 2014932582

For all general information, please contact Arcadia Publishing:
Telephone 843-853-2070
Fax 843-853-0044
E-mail sales@arcadiapublishing.com
For customer service and orders:
Toll-Free 1-888-313-2665

Visit us on the Internet at www.arcadiapublishing.com

To Willis M. "Bill" Baldwin

CONTENTS

ACKNOWLEDGMENTS

I would like to thank all the members of the Central Coast hot rod community who granted me access to their photograph collections and, more importantly, to their memories. Special thanks go to veteran race car driver, hot rodder, and true gentleman Lee Hammock for patiently sitting through the many hours of my relentless questioning. Thanks also go to Santa Maria Drag Strip founder Jerry Gaskill, my friends Jack Chard and Frank Viera, Don Lanning, Barry Atsatt, Fred Dannenfelzer, Ruben Martinez, Don Edwards, Hunter Self, Betty Roach, Jerry Williams, Walt Williams, Ambrose Little, Jesse Torres, and Willard Partch. For the chapter on the Baldwin Specials, I would like to thank Stephen Payne for generously providing a wealth of research material and valuable input, Stu Hanssen for his contributions to the Baldwin story and helping to get the whole project started, and Bill and Vicki Baldwin. Thanks also go to Mark Mendenhall for use of the archive at the Mendenhall Museum and for his time and help. For their invaluable work in the production of this book, I would like to thank Desiree Gonzales, text and layout editor, and Ryan Rush, image editor. For use of their excellent facilities, I would like to thank my close friends Adam Randall and Tiffanie Wright of the Squashed Grapes Wine Bar and Jazz House. For his continued support, thanks again go to my old friend Harry Mishkin. And thanks also go to my son, Thomas. Last but not least, many thanks go to Jeff Ruetsche and Elizabeth Bray at Arcadia Publishing for getting me started, and to Jared Nelson, Suzanne Lynch, and the rest of the staff at Arcadia. I have worked hard to make this pictorial history as accurate as possible, but please forgive the inevitable errors that will occur. I hope you enjoy reading it as much as I enjoyed putting it together.

INTRODUCTION

Most of the towns that sit alongside US Highway 101 in Santa Barbara County have made some type of contribution to the history of motor sports and hot rodding. From Carpinteria and its oval dirt track to Santa Maria's famous drag strip, almost any kind of automotive racing could be found in the region.

Probably the earliest hot rod action was jalopy racing. Based on prewar sprint car and dirt-track racing, jalopy racing took advantage of the abundance of used Fords and other older cars that became available as the postwar era progressed. Cheap, expendable, and easy to hop-up, the jalopies led to a fast, reckless, no-holds-barred type of racing, which produced the thrills and chills that the crowds of the late 1940s loved.

The biggest and most famous track on the coast was the Thunderbowl, located on a high bluff over the ocean south of Carpinteria, California. The quarter-mile, dirt, oval track was founded in 1946 by veteran sprint car racer J.F Slaybaugh and hosted such celebrity drivers as Parnelli Jones and Troy Rutman. Originally started as a midget-car track, it became dominated by jalopy racing around 1948, when it began drawing larger crowds. The Carpinteria Thunderbowl became a major attraction in the region as car culture began taking over America.

Like its neighbor to the south, Ventura County, Santa Barbara County had many of the same factors that led to a very active hot rod scene. Teenage car nuts, returned veterans who had been involved in the prewar hot rod scene, and oil-field mechanics were all present and began banding together. The earliest postwar group of local speed enthusiasts included Bob Joehnck and Lee Hammock. Like all the early California hot-rodders, the Santa Barbara boys had to choose between illegal street drags or four-hour trips out to El Mirage Dry Lake for its racing activities.

After the end of World War II, the federal government began closing down many of the military facilities dotting California's Central Coast. Two of these, Marine Corps Air Station Santa Barbara (located at the former municipal airport in Goleta) and Santa Maria Army Air Field, would be turned over to Santa Barbara County for civilian use. The two bases would eventually become municipal airports, although the large military airfields were more than the local communities required at the time. Along with well-constructed concrete runways, complete water and power systems, and various buildings, there were lots of unused access roads, hardstands, and taxiways that were perfect for other uses, like driving fast—*really* fast, with no traffic or stop signs to get in the way.

This was soon noticed by Bob Joehnck and others in the Santa Barbara area. They had wanted a place to race that was both legal and nearby, and Goleta looked like the perfect location. In the summer of 1948, Bob approached the friendly airport manager, a Mr. Swain, who quickly approved. Insurance was acquired through Lloyd's of London, and the Santa Barbara Acceleration Association (SBAA) was formed and in business. A long, straight perimeter road north of the runway—now known as Firestone Avenue—was chosen as the track. The starting line was near Cass Place, and the finish was where the road crossed Carneros Creek, roughly a quarter of a mile.

An unused lifeguard tower was procured from the beach for use as a timing stand, and this was connected to the finish line by telephone equipment that the Marines had abandoned when they left the air base. It cost $1 to get in and watch; there were no grandstands, and refreshments were provided by a catering truck. And so was born the first quarter-mile drag strip in the country. The SBAA also laid out a rough track around an abandoned air base warehouse north of the starting line across Hollister Avenue for when drivers got tired of racing in a straight line.

Shortly after this, the newly formed California Sports Car Club (CSCC) moved into the northeast corner of the airport for some European-car road racing. Imported exotics like the Talbot-Lago, MG TC, and Jaguar XK 120 were raced there, as were a few locally designed and built specials. One of the specials—built by Montecito resident Willis Baldwin, driven by Englishman Philip Payne, and made up of off-the-shelf Ford speed parts on a modified 1932 frame—gave the imports a run for their money when it took first place at the CSCC time trials on August 7, 1949. This rod, or more properly, "sport rod," went on to a successful racing career in Southern California and later in England, where it created quite a controversy.

European-car enthusiasts tended to be more gentlemanly than the hot rod guys, and while the two groups did not generally associate with each other, they still managed to coexist with no problems. The SBAA ran a pretty efficient operation, able to pay expenses and still have enough money left over for the occasional beer bust. There were a few problems, though. When a car crossed the finish line at Carneros Creek, there was very little room to slow down, and the dragsters kept crashing through the gate that marked the end of the airport. Also, the responsibility of running a successful operation became too much for the members of the SBAA, and they decided to quit in 1951. Sports car racing would continue at Goleta until the early 1970s.

The drag-racing action soon moved south to the Marine air station at Santa Ana, California. A Santa Maria businessman and hot-rodder, Jerry Gaskill got tired of taking the long drive down to Santa Ana and decided to do something about it. After successfully lobbying the airport commissions of San Luis Obispo and Santa Maria, he established drag strips at both airports. Santa Maria would become the more famous of the two, hosting everyone who was anyone throughout the 1950s and 1960s.

Hot rod culture never really died out on the Central Coast. The surviving old-timers are still building and showing cars, although their numbers are dwindling. The towns along Highway 101 all have one or more car clubs. Some, like Santa Barbara, have several. There are numerous car shows for every variety of hot rod or classic car each season. The north county seems to be as active as ever with a popular dirt track in Santa Maria, and the big hot rod community in Lompoc has plans for a new drag strip. A new generation of hot-rodders is on the scene now, and it looks like hot rodding in Santa Barbara will go on for some time to come.

One

CARPINTERIA'S THUNDERBOWL

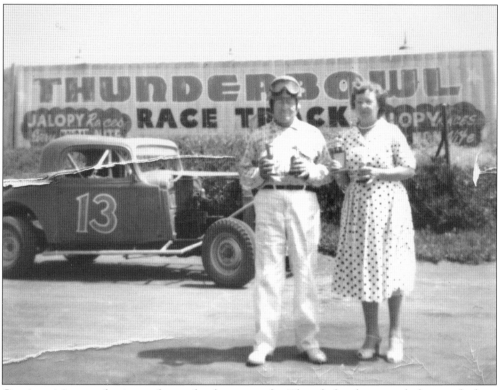

Carpinteria's contribution to hot rod culture was the Thunderbowl racetrack, home of jalopy racing. Owner J.F. Slaybaugh, pictured here in 1958 with his wife, Pearl, was an old sprint and midget car racer from the 1930s who still enjoyed an occasional run on the track. That is his orange Pontiac coupe in the background. Charging $1.25 admission (children were free), Slaybaugh made the Thunderbowl the biggest of a string of half-mile dirt tracks that stretched from Oxnard to Santa Maria by offering a full night's entertainment to the people of the late 1940s. Besides a night of action-packed jalopy racing, he had special events like "powder puff derbies" (featuring all female drivers), gave away television sets, and even offered free bubble gum to the kids. Racing at the Thunderbowl started in 1947 and would go on until the early 1960s when the Highway 101 expansion project reached the track. The California Department of Transportation needed somewhere to put all the earth that would be displaced when it cut the highway through nearby Rincon Point, and unfortunately, the Thunderbowl was the perfect location. The department made Slaybaugh a large cash offer, and he accepted, sealing the racetrack's fate. (Courtesy of Lee Hammock.)

The Thunderbowl was a large, bowl-shaped depression at the top of the bluff overlooking Rincon Point, where Highway 150 meets Carpinteria Avenue. The view in this very early image from 1947 is looking toward the ocean. A high wooden fence would soon be erected on the earth berm in the background. Owner J.F. Slaybaugh lived in a ranch house on the property. (Courtesy of Lee Hammock.)

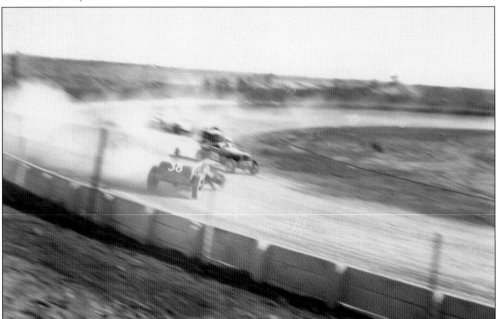

A Ford roadster spins out on the east turn at the Thunderbowl, kicking up a cloud of dust. Incidents like this, while rarely fatal, began attracting large audiences during the postwar era. These early meets, made up of local lake racers, would soon evolve into the immensely popular sport of jalopy racing. (Courtesy of Lee Hammock.)

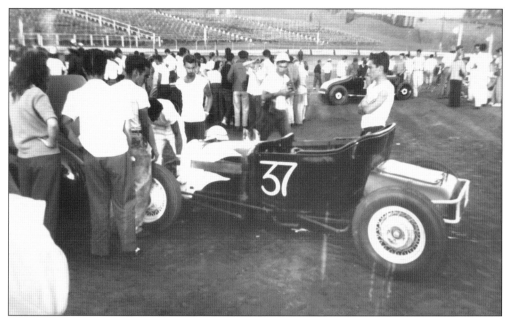

This view, taken on a hot and muggy day in 1947, is facing roughly north. Old Highway 1, now known as Carpinteria Avenue, runs along the top of the slope in the background. The grandstands were simple wood-plank benches stepping up the slope. This whole area is now under several feet of dirt moved there from the Highway 101 expansion project during the 1960s. (Courtesy of Lee Hammock.)

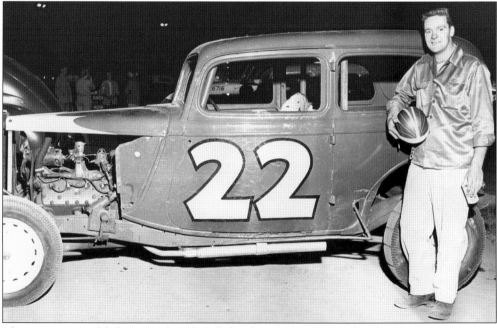

The most successful driver at the Thunderbowl was Lee Hammock. The Missouri native was active in every type of racing in California during the 1940s and 1950s. Lee is seen here posing with a chartreuse-and-white Ford Tudor that was sponsored by the Liberty News Service and Peri's Garage. (Courtesy of Lee Hammock.)

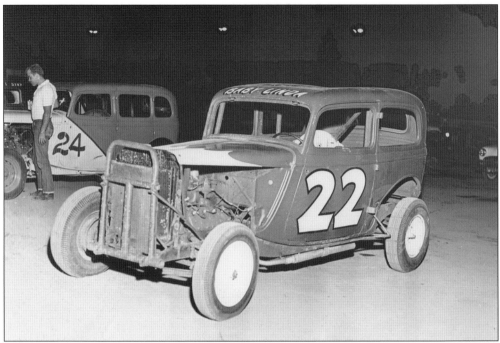

Here is another shot of the attractively painted jalopy racer. The words "Baby Linda" painted above the windshield refer to Marino Peri's youngest daughter. No. 22 appears to be in unusually pristine condition for a jalopy racer; this would not last. (Courtesy of Lee Hammock.)

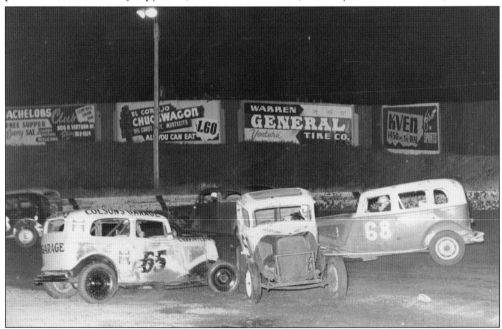

Here is a classic jalopy-race pileup. Lee Hammock (left, driving the yellow 1934 Ford Tudor for Colson's Garage of Carpinteria) seems to be going in the wrong direction as he engages another Ford during this 1947 race at the Thunderbowl. Note the billboard in the background for the Chuckwagon Restaurant in Montecito, advertising dinner for $1.60. (Courtesy of Lee Hammock.)

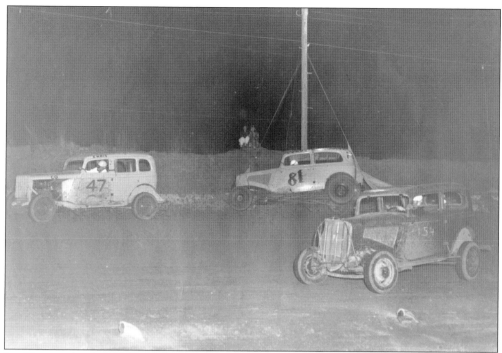

Lee Hammock, in No. 81 at center, hits the earthen berm in his very first race at the Thunderbowl. These were in the early days at the track, before the wooden fence was erected. The couple just visible seated on the berm above Lee must have gotten quite a thrill. (Courtesy of Lee Hammock.)

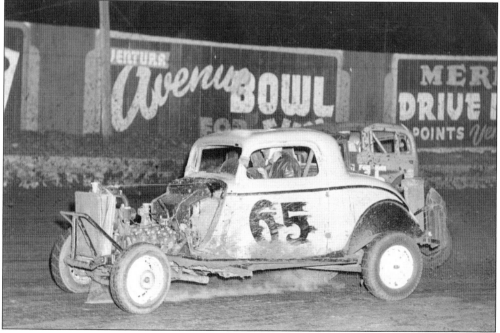

In this shot, Lee Hammock is in another yellow-and-black jalopy for Colson's, this time a 1934 Coupe. From the looks of it, the jalopy's radiator has been split in a collision with the car just behind it. Note how the coolant has just begun to leak out. (Courtesy of Lee Hammock.)

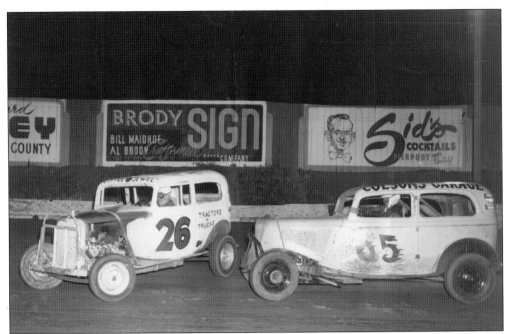

During a jalopy race, if a driver could push an opponent out of the way rather than pass him, so much the better. Here, it looks like Lee Hammock in No. 65 is about to broadside the car that made the mistake of cutting in front of him. The still-intact grill shell on Lee's car is going to take a beating. (Courtesy of Lee Hammock.)

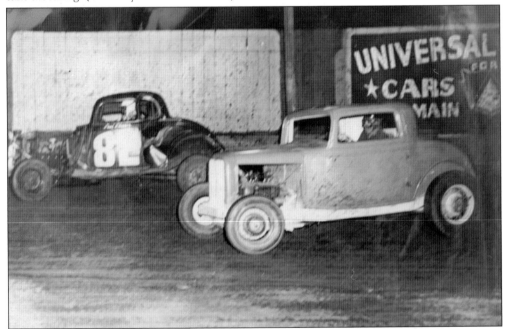

Another well-known driver at Carpinteria was Keith Loomis of Ojai, who also seemed to be everywhere in the late 1940s. Here, he is in one of his first races (right), driving a 1932 Ford powered by an illegal 1933 Model C engine. Note the pristine blue-and-yellow coupe body on his jalopy. It would not stay in that condition for long. (Courtesy of Keith Loomis.)

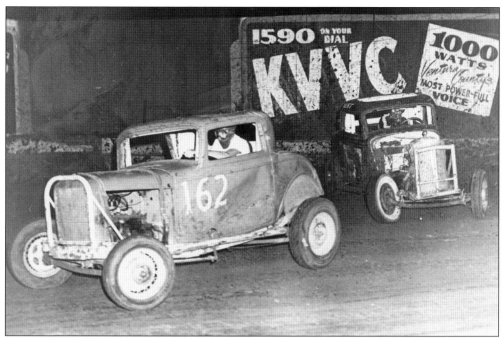

Here, the battered coupe is seen a little later. The late-build four-cylinder Ford engine had a milled head, Smith camshaft, and a Winfield carburetor and manifold. The lighter engine gave the car better handling than the heavier V-8–powered competition, which tended to slide. This also made Loomis very unpopular with the other drivers, who rammed him whenever they got the chance. (Courtesy of Keith Loomis.)

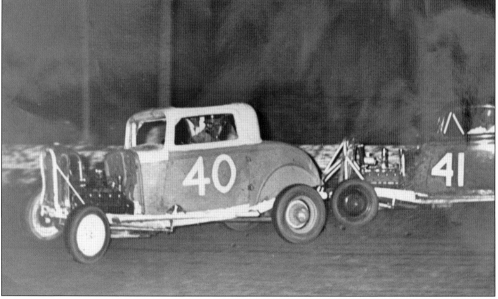

Pressure from his sponsor and the treatment he was receiving from the other drivers finally convinced Loomis to replace the engine with a proper V-8, seen here. He was very successful with the four-banger, approaching second and third place on days when as many as 50 cars were in the heats. (Courtesy of Keith Loomis.)

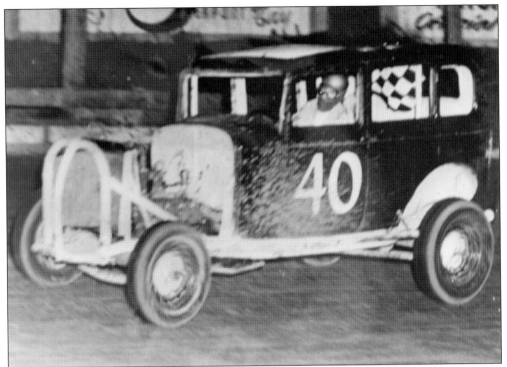

By 1951, Loomis replaced the unpopular coupe with this maroon-and-light-blue 1932 Ford sedan. The early, 21-stud Ford flathead that powered this car was a requirement in jalopy racing. Loomis, pictured here taking a victory lap at Carpinteria, is wearing an aluminum "chrome dome" climbing helmet, favored by many drivers for its economy until it proved unsafe. (Courtesy of Keith Loomis.)

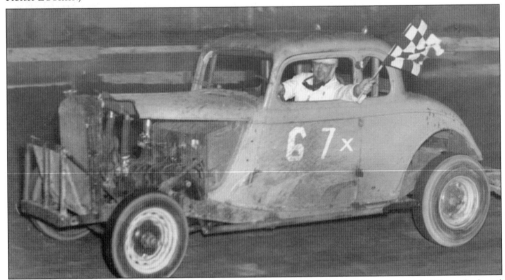

Santa Barbara's "Wild Bill" Cherry is seen taking a victory lap at Carpinteria's Thunderbowl racetrack in his cherry-red 1932 Ford jalopy racer. He was so named because of his reckless driving style. Personalities like Cherry could be seen at the Thunderbowl every Monday night during the racing season. (Courtesy of Jesse Torres.)

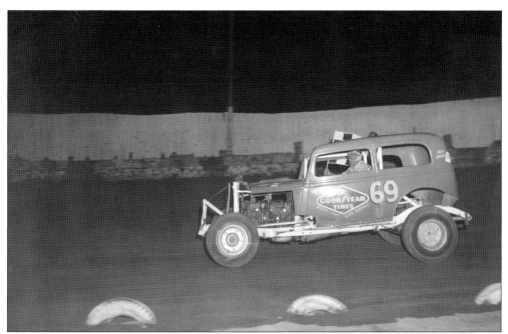

Lee Hammock waves the checkered flag as he makes a victory lap around the Thunderbowl on the night he won the Trophy Dash in 1956. The orange-and-white Chrysler set a track record that stood until the track closed eight years later. (Courtesy of Lee Hammock.)

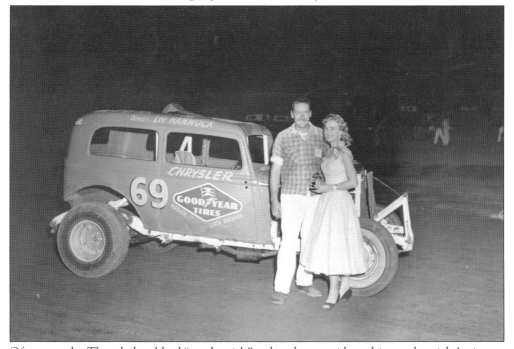

Of course, the Thunderbowl had "trophy girls" to hand over said trophies to the night's victors. Here, a smiling Lee Hammock is the recipient. Besides the Swing Club, Hammock's very successful Chrysler was also sponsored by the Marvin Light Tire Company of Santa Barbara. (Courtesy of Lee Hammock.)

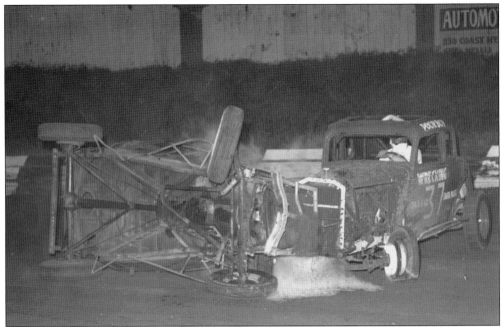

Ventura driver and gas station owner Pete Gallagher goes over on his side as water gushes from his radiator in this Monday-night commotion at the Thunderbowl. The lettering on the side of the jalopy at right appropriately says "wrecking." This image also gives a good view of the underside of a 1934 Ford. (Courtesy of Pete Gallagher.)

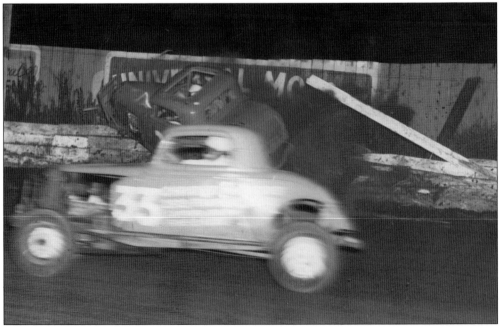

This jalopy has completely lost its front axle in a collision with the barrier on the east turn at the Thunderbowl as another racer flashes by. In spite of frequent wrecks like this one, there were actually very few serious injuries during the whole time the track was in operation. (Courtesy of Pete Gallagher.)

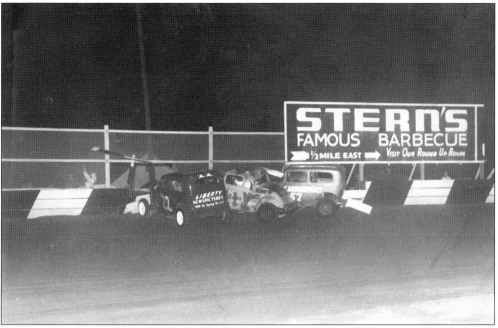

Here is a great action shot as Lee Hammock, in a tangle with two other jalopies, goes through a fence at the track at Gardena, California. Note the flying planks and the spectators scrambling for cover on the left. Fortunately, no one was hurt during this exciting mishap. (Courtesy of Lee Hammock.)

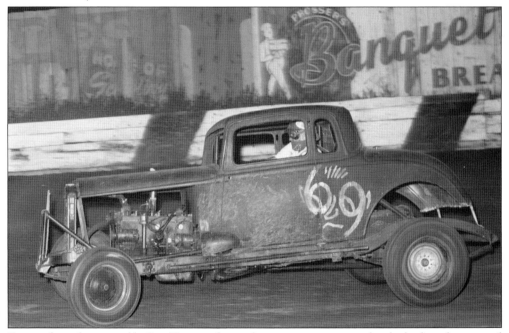

Yet another jalopy raced by Lee Hammock was this primer-gray coupe that he built and co-owned with Robert MacFarland. What is unusual about this vehicle is that it is a 1933 Chrysler coupe rather than a Ford. The 1934 Ford was the dominant type used in jalopy racing. This Chrysler was powered by its original six-cylinder engine. (Courtesy of Lee Hammock.)

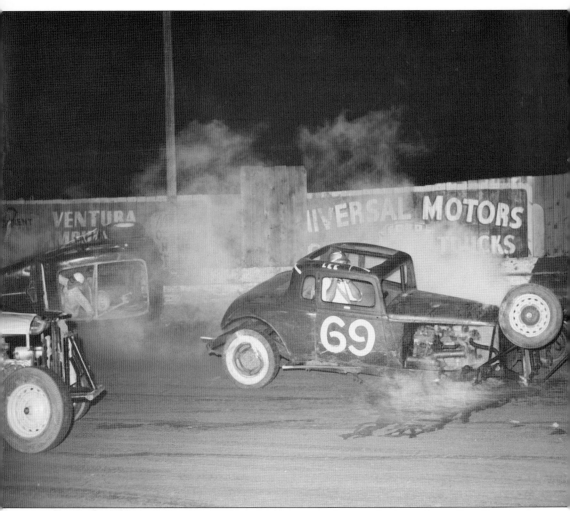

The Chrysler met its end in 1954, as shown in this image. Lee smashed into the wall at Carpinteria after colliding with the car on its side at left, completely snapping off the whole front-axle assembly. As was usually the case, no one was hurt. (Courtesy of Lee Hammock.)

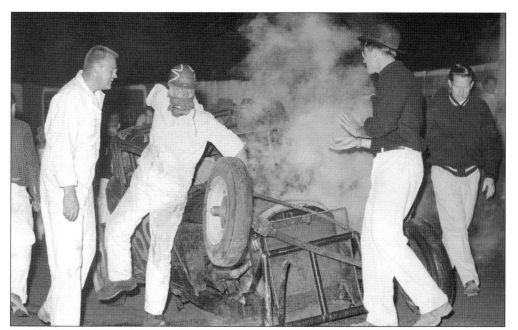

Crawling from the wreckage, Lee Hammock exits the now smashed Chrysler. His partner, Robert MacFarland, is on the left, while Tri-County Racing Association president Randy Claus (center right) and local hot-rodder and Santa Barbara Acceleration Association founder Bob Joehnck (far right) survey the scene. (Courtesy of Lee Hammock.)

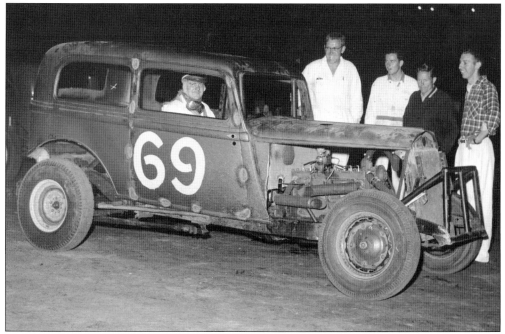

Lee removed the engine from the wrecked coupe and installed it in the 1933 Chrysler sedan. Note how the exhaust came straight out of the short headers on the side of the engine. Standing, from left to right, are Robert MacFarland, an unidentified mechanic, Goleta Drag Strip founder Bob Joehnck, and Paul Vanderley. (Courtesy of Lee Hammock.)

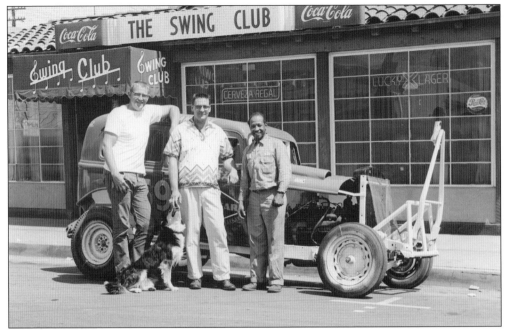

By 1955, the Chrysler had gained a coat of orange paint with white trim and a sponsor. The Swing Club was a popular tavern at 628 East Haley in Santa Barbara owned by George Simpson. Standing, from left to right, are Robert MacFarland, Lee Hammock, and Simpson. Note the tow bar and heavy front nerf bar that have been installed on the sedan. (Courtesy of Lee Hammock.)

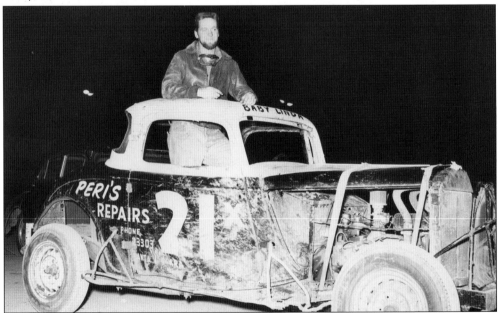

Around 1950, Lee Hammock began to be sponsored by Marino Peri's Garage of Goleta while driving this red-and-white Ford coupe. Protecting the rear wheels and the radiator are structures made of bent steel bars known as nerfing or nerf bars. Chrome-plated, simplified versions of these would become a common stylistic touch on hot rods throughout the 1950s. (Courtesy of Lee Hammock.)

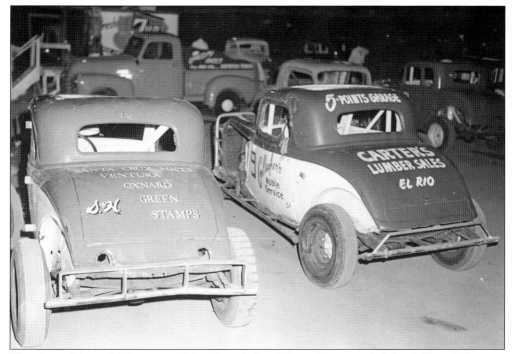

This shot of the infield pit area of the Thunderbowl shows how crowded the field could be on a Monday night. These two coupes were both owned by Pete Gallagher. The green-and-white one on the left was driven by Bill Potter of Ventura, and Gallagher himself drove the red-and-white example on the right. (Courtesy of Pete Gallagher.)

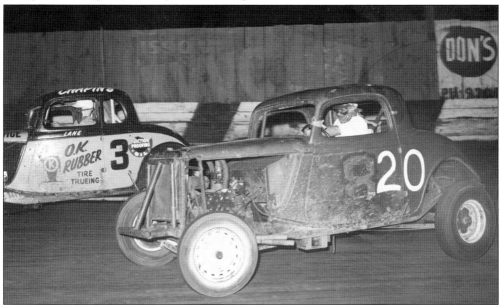

Buford Lane (left, driving a coupe sponsored by Chapin's Tires of Santa Barbara) engages in a passing duel with Lee Hammock (right, in No. 20) at the Thunderbowl. This image was taken some time later in the racetrack's career, as evidenced by the faded advertising on the wooden fence in the background. (Courtesy of Lee Hammock.)

When Lee Hammock was not racing sponsored cars, he raced his own. Here, he is drifting his light-blue-and-coral-pink 1934 Ford sedan around the curve at Carpinteria. Jalopy racers were usually painted in bright colors that provided eye appeal for the crowds of spectators and also helped them identify who was who on the track. (Courtesy of Lee Hammock.)

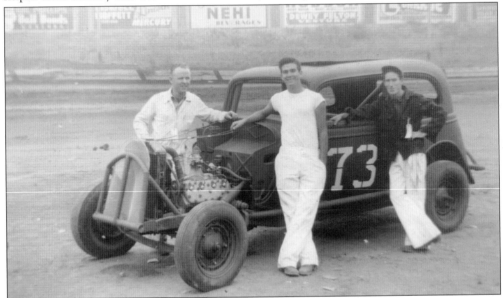

Here are three Carpinterians—Ernie McGuiness (left), Buzz Barker (center), and Hank Curnao—at the Thunderbowl with their 1934 Ford Victoria jalopy in 1952. Lee Hammock, who was everywhere in those days, helped build this one and even drove it a few times. That rare steel Victoria body shell would fetch quite a price on today's market. (Courtesy of Lee Hammock.)

Two

SANTA BARBARA

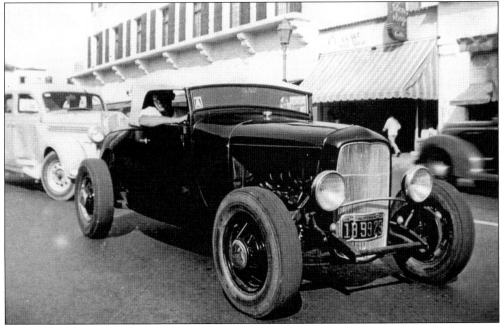

Back at the start of World War II, Santa Barbara was a quiet, well-to-do resort town with a small handful of car enthusiasts. High school student Bob "Bagsey" Benedetto of Santa Barbara is seen here on State Street near Figueroa Street in early 1942, just before he left to serve in the military. Note the gasoline-ration stamp on his windshield. The black 1929 Ford roadster has a 1932 grill and 1930 headlights. (Courtesy of Jack Chard.)

Here is another view of Bob Benedetto's Model A, taken on the same day. The hot rod is parked in front of a candy and tobacco shop on State Street, not far from the Montgomery Ward department store. There does not seem to be much foot traffic in this early-wartime sidewalk view. (Courtesy of Jack Chard.)

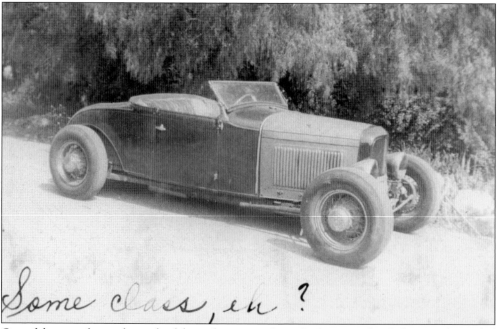

One of the more famous hot rods of the early scene in Santa Barbara was this dark green channeled 1931 Ford roadster, known as the "Gopher." It got that nickname because it sat unusually low for a hot rod of that period. This attractive roadster was seen all over town in the prewar days and early 1940s. (Courtesy of Jack Chard.)

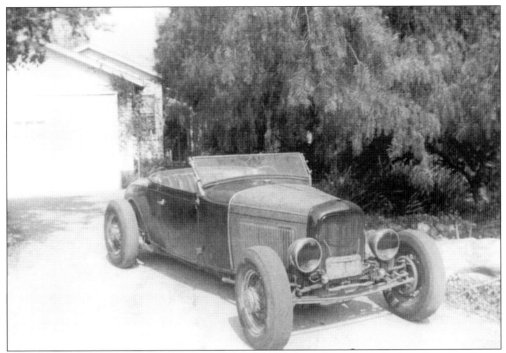

The origins of the Gopher are not clear, but it is thought to have been built in Los Angeles in the late 1930s. The early hot rod went through many local owners during the war years before disappearing sometime in the mid-1940s. (Courtesy of Jack Chard.)

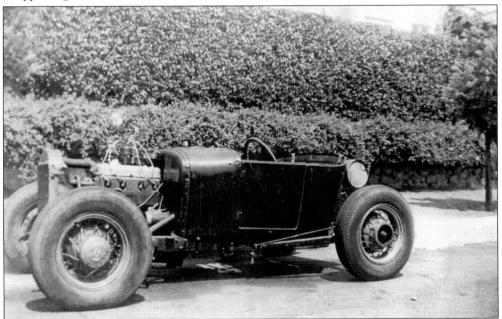

Another famous, or infamous, local hot rod was known as the "Jeep." Possessing an obscure past and having multiple owners, this dangerous-looking 1926 Model T was seen tearing all over town in the old days. That looks like a late Model A Ford four-banger with some type of aftermarket head in the engine compartment. (Courtesy of Jack Chard.)

This typical but good-looking 1929 roadster has been fitted with the usual 1932 grill shell. Of interest are the cut-down windshield and aftermarket "beehive" oil filter and cooler seen mounted on the AB-block V-8 engine. It has a 1932 front axle and mechanical (rather than hydraulic) brakes. (Courtesy of Jack Chard.)

Pictured somewhere on Santa Barbara's west side in 1941 is this somewhat rare custom 1934 Ford cabriolet (note the glass rear window). The owner has removed the front fenders but kept the rear ones and added some fender skirts. The rear end has been decked. Note also the post-mounted spotlight. (Courtesy of Jack Chard.)

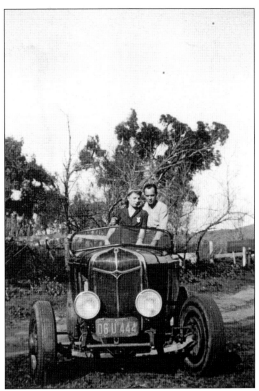

These two images from 1941 show a hot rod belonging to Santa Barbara resident Jack McNally. A 1932 Ford roadster, the rod has been given a distinctive look by the addition of a grill shell from another make, possibly Chrysler or DeSoto. This was a not uncommon practice among hot rod builders in the early days, with Packard grills also being a popular substitute for the usual Deuce or Model A shells. The Ford was powered by a 21-stud flathead V-8 equipped with dual carburetors, most likely the one it left the factory with. The hinged windshield is a modified unit from a 1937 Ford. (Both, courtesy of Jack Chard.)

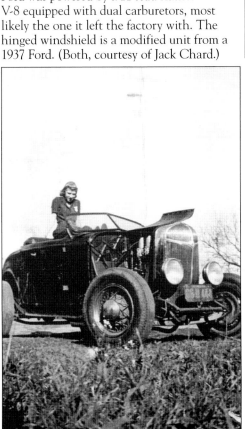

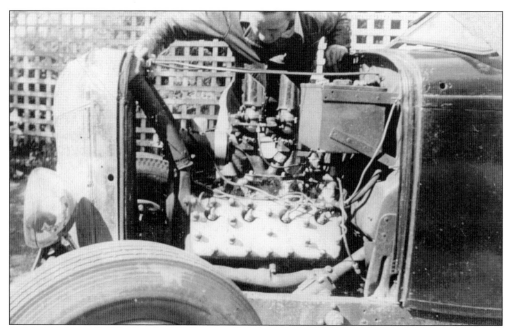

Jack McNally examines the flathead on his hot rod. Note how the twin carburetors are mounted on an Edlebock "slingshot" intake with the carburetors up on extensions in order to clear the top-mounted generator on this early V-8 engine. (Courtesy of Jack Chard.)

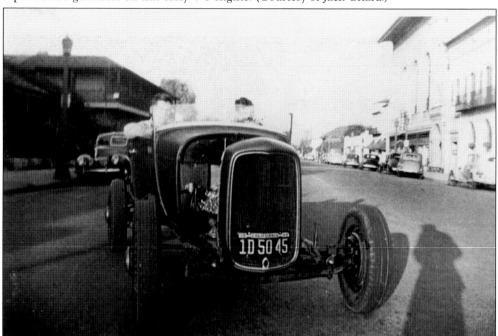

Here is another example of a Ford hot rod from 1942, seen on State Street, just south of Figueroa Street. A 1932 Deuce grill shell combined with the 1929 roadster body made for what was probably the most eye-pleasing hot rod configuration there was. The 1932 I-beam front axle used on this rod was preferred by hot-rodders because it was "dropped" 1.5 inches lower than the 1929 axle. (Courtesy of Jack Chard.)

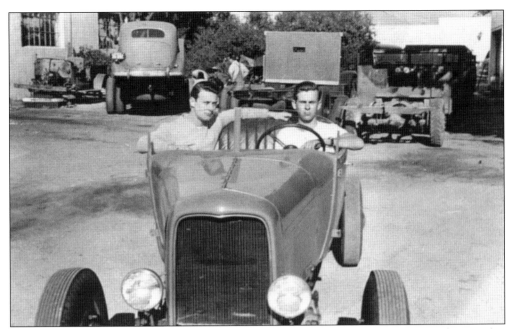

Alan Jennings was another well-known local hot-rodder in the early 1940s. Here he is in his green 1929 Ford roadster just prior to entering the military. His passenger is unidentified. The location appears to be a garage somewhere east of State Street in Santa Barbara. (Courtesy of Jack Chard.)

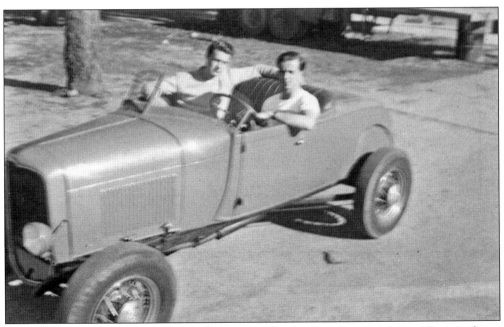

The clean and simple appearance of Alan Jennings's rod is evident in this image. Cars similar to this one were on streets all over California by the early 1940s and became the prototypes for most of the hot rods seen over the last 70 years. Jennings's roadster would soon go into mothballs as he too entered the military; it would be rebuilt on his return. (Courtesy of Jack Chard.)

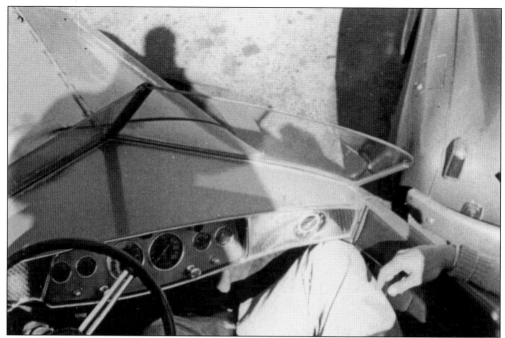

This is the well-crafted dashboard of Alan Jennings's roadster. Fabricated by Jennings himself using elements from a 1932 Ford, the Stewart-Warner gauges are nicely laid out. Alan Jennings had a talent for making dashes and did a few for other local hot rods and customs. The speedboat-style windshield was made by Jennings too. (Courtesy of Jack Chard.)

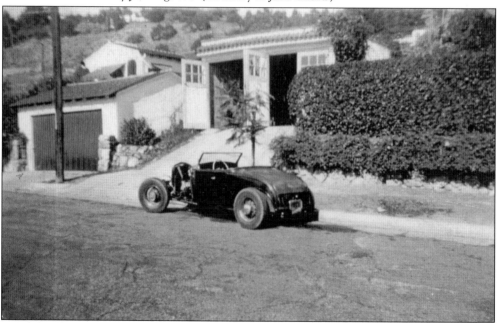

This shot shows the Gopher parked across the street from the McNally residence on Robbins Street. As can be seen in this picture, there was a lot more open space in Santa Barbara back in the 1940s. This neighborhood has been densely developed since this image was taken. (Courtesy of Jack Chard.)

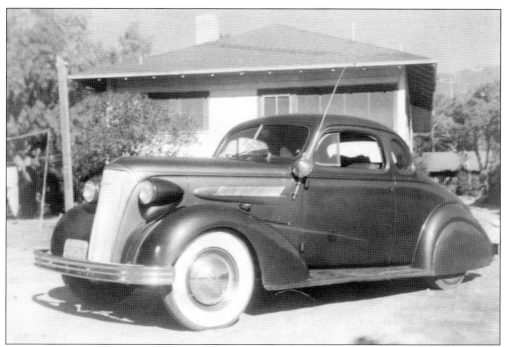

Dick Jacobs of Santa Barbara drove this metallic purple 1937 Chevrolet coupe, pictured here in Montecito at Lee Hammock's home. He has put "high-lows" on it, that is, larger wheels on the front for a cooler look. Whitewall tires, a spotlight, long whip antenna, and rear fender skirts top off this late-1940s custom. (Courtesy of Lee Hammock.)

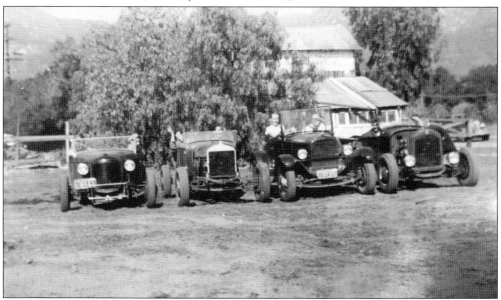

This lineup of hot rods from 1949 is parked in front of Lee Hammock's garage/workshop at 610 East Valley Road in Montecito and features some of the "all-stars" of the Santa Barbara hot rod scene. From left to right are Fielding Lewis, Keith Loomis, Rip Erickson, and Keith Purrington. Hammock is behind the camera, and his 1937 Chevrolet is just visible at far right. (Courtesy of Lee Hammock.)

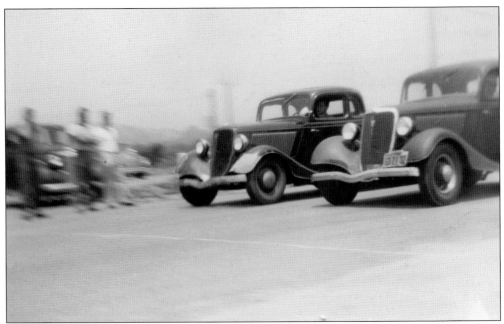

A pair of 1934 Ford coupes driven by Santa Barbara locals Dave Malis (right) and Jack Mulhart (left) duke it out on the strip at Goleta in 1948. Jack's family owned the Mulhart Electric Company of Santa Barbara. (Courtesy of Lee Hammock.)

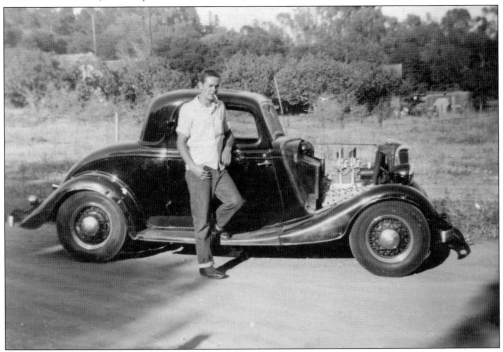

Among the many hot rods owned by Lee Hammock, this sharp full-fendered 1934 Ford coupe was particularly nice. Lee is posing with it at his family's home in Montecito. Note how the Stromberg carburetors are mounted on risers to clear the generator on the early 21-stud flathead engine. (Courtesy of Lee Hammock.)

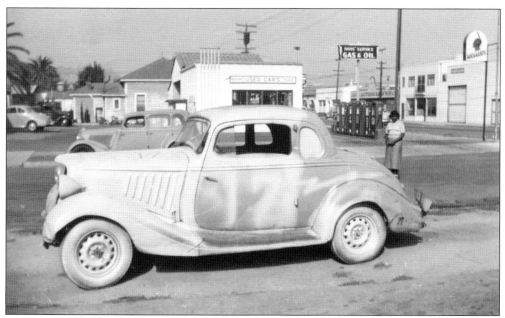

This shot, taken in the 1950s on Haley Street in Santa Barbara, shows a 1935 Hudson coupe that Lee Hammock and Rip Erickson bought with an idea to make a jalopy racer out of it. Unfortunately, Erickson wrecked the car before that was possible. The businesses visible in this shot have all changed, but the buildings remain largely the same. (Courtesy of Lee Hammock.)

Besides building hot rods and jalopy racers, Lee Hammock also tried his hand at customs. This 1940 Mercury sedan has been nosed and decked, and that is part of a 1947 Cadillac grill up front with a 1946 Mercury front bumper. As with most hot-rodders, Lee kept the custom for a short time before selling it off. (Courtesy of Lee Hammock.)

Lee Hammock's dad, Lee Hammock Sr., is seen here relaxing during a family party in Montecito. Hammock Sr. was an old race car driver and builder himself, having barnstormed midget racers throughout the Midwest during the 1920s and 1930s before bringing his family out to California. He worked as a chauffeur for a wealthy family in Montecito and was completely supportive of his son's career in racing. (Courtesy of Lee Hammock.)

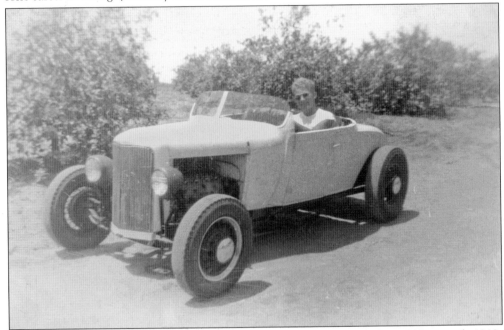

This white, flathead-powered 1929 Ford roadster is a good example of a late-1930s or early-1940s hot rod. It was built by Bob Cosper of Santa Barbara, who is seen here behind the wheel. Note the homemade windscreen and the DeSoto grill shell. DeSoto grills were seen on quite a few early Santa Barbara hot rods. (Courtesy of Lee Hammock.)

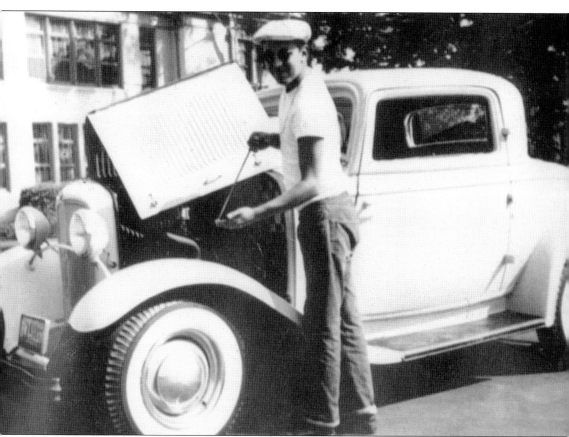

Frank Keeler of Santa Barbara is seen here checking the oil on his white 1932 Ford three-window coupe in front of Santa Barbara High School in 1953. Frank would be tragically killed in a road accident during the early 1960s while towing his dune buggy up from Baja California. (Courtesy of Frank Viera.)

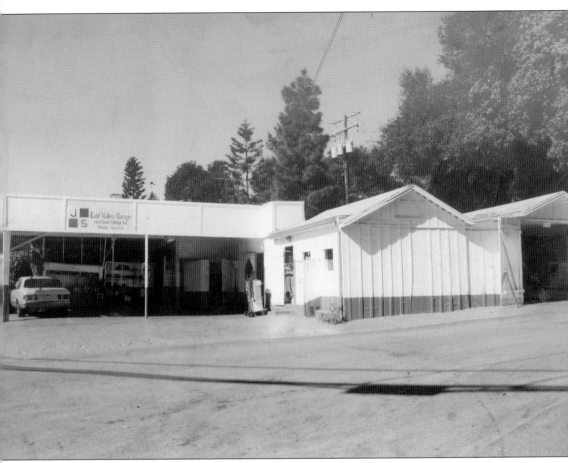

The J&S Garage at 1610 East Valley Road, Montecito, has been has been in continuous operation for nearly a century. Started in 1919 as a limousine service for the wealthy families in the area, the business soon became a general automotive garage when purchased by Elroy Jenkins in the 1920s. Jenkins operated the garage until 1964, when he retired and sold it to Jay Roach of Santa Barbara. Under Roach's ownership, the garage became a Philips 66 service station and also became known as a meeting place for the local hot-rodders. Roach would build many successful Bonneville racers there as well as quite a few hot rods. The gas crisis of the early 1970s put an end to Roach's days as a Philips 66 dealer, but he kept the garage open as a repair shop. From then until Roach's death in 2012, building engines and hot rods became the main part of the business, although it still did general automotive repair. After Roach's death, the garage was purchased by employee Hunter Self, who operates the business in the same tradition as did Roach. (Courtesy of Hunter Self and Betty Roach.)

Jay Roach built this fast-looking 1931 Ford Model A sedan back in the late 1950s. An accomplished engine builder, Roach has put a blown Oldsmobile Rocket V-8 in the engine compartment. It was white with red wheels, and note the cover over the blower stacks that are sticking out of the hood. (Courtesy of Hunter Self and Betty Roach.)

Here is a close-up of the blown Oldsmobile engine in Jay Roach's hot rod. He must have used it on the street, because he has installed sealed-beam headlights. The intake stacks sitting atop the six Stromberg carburetors have been made from 16-ounce Olympia beer cans. Pictured are Jay (at right, behind the blower), Fred Dannenfelzer (center), and Jay's wife, Betty (left). (Courtesy of Hunter Self and Betty Roach.)

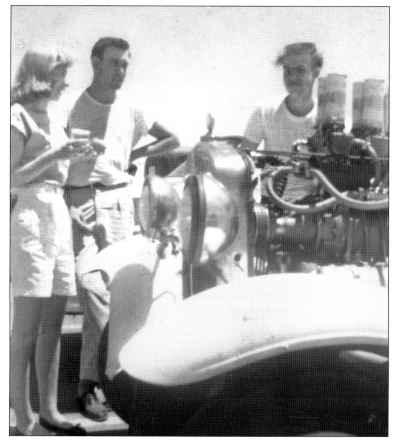

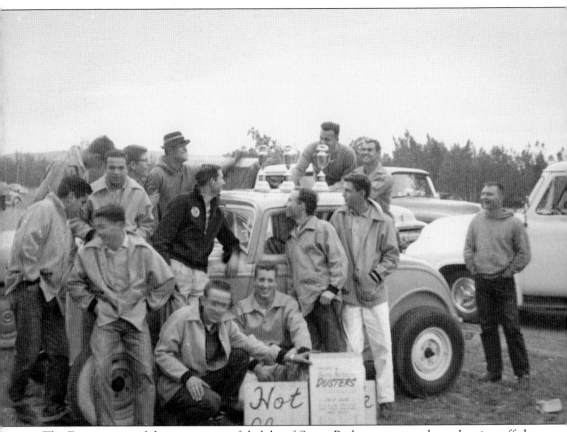

The Dusters, one of the more successful clubs of Santa Barbara, are seen here showing off the trophies won by members during a meet at Santa Maria. Quite a few of the Dusters' yellow club jackets are visible. The club logo was a wheeled broom taking off in a cloud of dust. The Dusters were founded in 1952. (Courtesy of Jack Chard.)

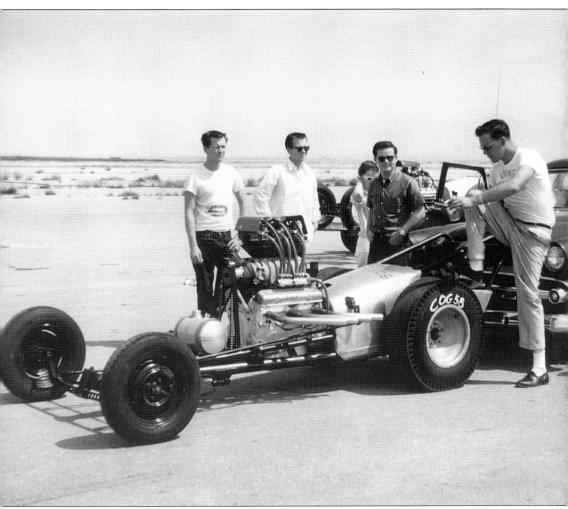

Fred Dannenfelzer (right) is seen here in 1959 at Merced with one of his early dragsters. A member of Santa Barbara High School's class of 1956 and a founding member of the Dusters car club, Fred would also become famous as a builder and driver of both drag racers and Bonneville Salt Flats racers. As of this writing, he holds the record for open-wheel cars (with a speed of 366 miles per hour) and is preparing a new racer for another run. The dragster in this image is powered by a blown 265-cubic-inch small block Chevrolet with three Stromberg 97s on top. The well-designed frame was homemade, as was the rest of this solid-looking dragster. Also visible are, from left to right, brothers John and Jim Langlo of Santa Barbara and an unidentified local hot-rodder. (Courtesy of Fred Dannenfelzer.)

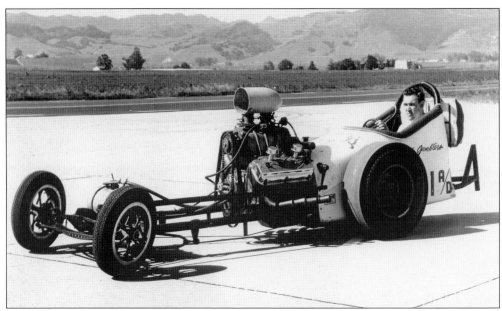

Besides being in the Dusters, Fred Dannenfelzer was also in the Grave Gamblers car club. Here is another of his drag racers, this one from around 1960. Fred has switched to a blown 392-cubic-inch Chrysler Hemi for power. Note also that the blower is chain driven rather than belt driven. The frame and body are again homemade, and it looks like he has used the same dropped axle as on his earlier car. Below, Fred is seen just as he lifts his front wheels off the starting line at San Luis Obispo. That is a Volvo 544 in the upper-left background. (Both, courtesy of Fred Dannenfelzer.)

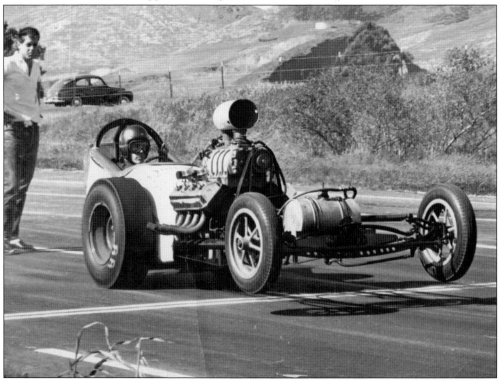

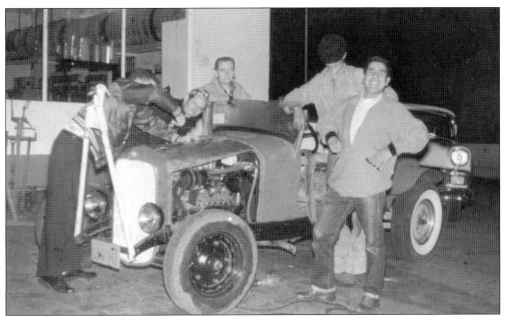

Here, a group from the Dusters clowns for the camera while working on Eric Salter's 1927 Model T roadster at the Richfield service station that used to be at the corner of State and Mission Streets. From left to right are Jack Chard (bent over the engine with his face not visible to the camera), Eric Salter, Don Adams, Gus Raymer (with hat over his face), and Gilbert Angulo. (Courtesy of Jack Chard.)

Santa Barbara native Jack Chard is seen here at age 14 with his first hot rod, a channeled 1927 Model T pickup powered by a Model A four-cylinder engine. Jack caught the hot rod addiction at an early age and, as an adolescent, hung around in the background at tracks like Goleta and Santa Maria before becoming a member of the Dusters car club. (Courtesy of Jack Chard.)

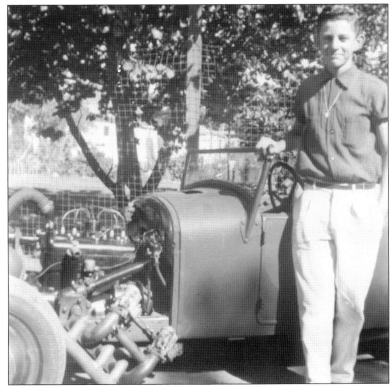

By the next year, the pickup had been replaced by this chopped 1932 Tudor sedan. Jack, age 15, is at right, draped over the fender. The location is his family's home, a historic adobe house on San Pascual Street in Santa Barbara's west side. Jack was fortunate enough to be at the right place at the right time and got to meet many of racing's early greats. (Courtesy of Jack Chard.)

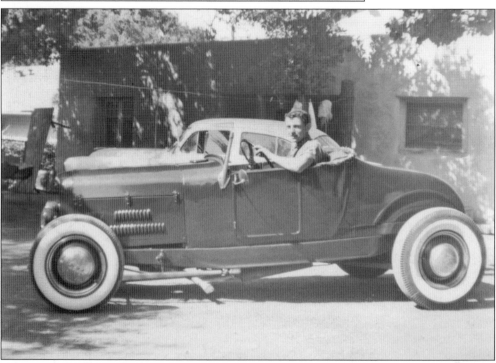

When Jack finally reached 16 years of age (legal driving age in California), he acquired this flathead-equipped 1927 Model T roadster. A born hot-rodder, he continues to run old Fords at shows up and down the coast. (Courtesy of Jack Chard.)

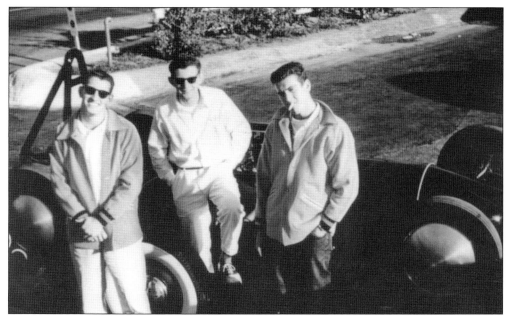

Like all car clubs, the Dusters would travel to drag strips in neighboring counties. In this image from December 1957, Bruce McGee (left), Jack Chard (center), and Art Castignola (right) have stopped for a picture on the way south to San Fernando's drag strip. Like the Motor Monarchs of Ventura, the Dusters adopted the white pants and shirt with the club jacket as standard attire while at the strip. (Courtesy of Jack Chard.)

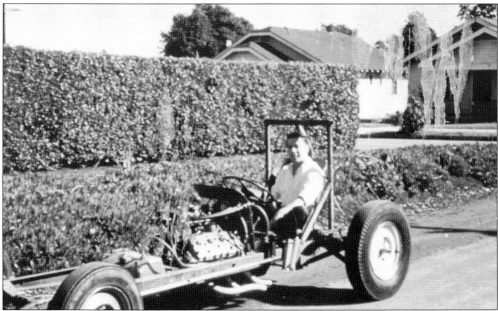

Dick Griffin was another local hot-rodder who would occasionally drive for the Dusters. He is seen here with his homemade dragster across the street from his parents' house on Gillespie Street in Santa Barbara's west side. This is as basic as it gets, just a pair of Model A frame rails and a 21-stud flathead V-8. The hand pump for pressurizing the fuel system is visible below Griffin's knee. (Courtesy of Jack Chard.)

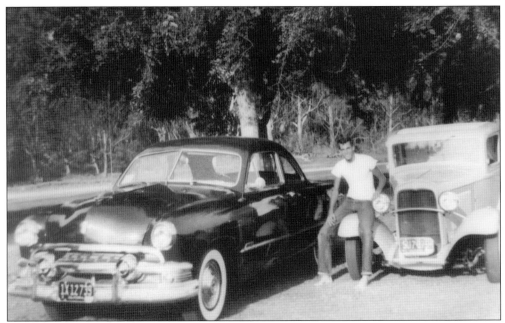

Lee Hammock used this cool black 1951 Ford Business Coupe (right) as his everyday family car during the mid-1950s. Parked next to him on this hot day in Montecito is Santa Barbara resident Doug Powers, sitting on the fender of his yellow chopped 1932 Ford coupe. In the background is East Valley Road, also known as Highway 192. (Courtesy of Don Lanning.)

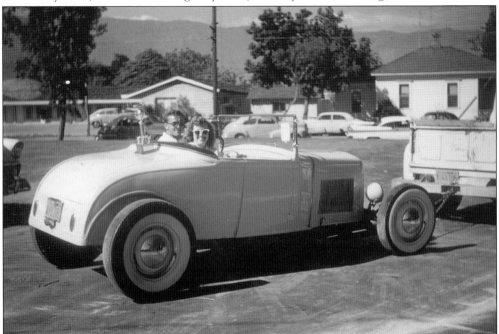

Walt Williams of Ojai and his wife, Ronda, sit proudly in his neat little yellow 1931 Ford roadster. Williams has just won first place at a car show held at Santa Barbara High School in 1959. He has installed King Bee headlights and used old-school (by 1959) lever shocks. (Courtesy of Walt Williams.)

One of the most popular pin-stripe artists on the Central Coast was Jesse Torres, who was known to the local hot-rodders as "Vonte." Quite a character, Vonte worked Ventura and Santa Barbara Counties. He is seen here plying his trade on a 1955 Mercury at a Vallejo, California, car show. (Courtesy of Jesse Torres.)

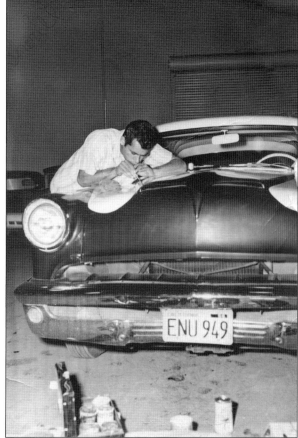

One of the longest-lasting clubs in the region has been the Santa Barbara Igniters. In this group shot taken in front of Santa Barbara High School are, from left to right, Dave Boccalli, Sam Foose, Tony Cavalli (driver's seat), Phil Salter, Barry Atsatt (in jacket), Dick Jeffers, Karl Hove, and Ben Rockwell. (Courtesy of Barry Atsatt.)

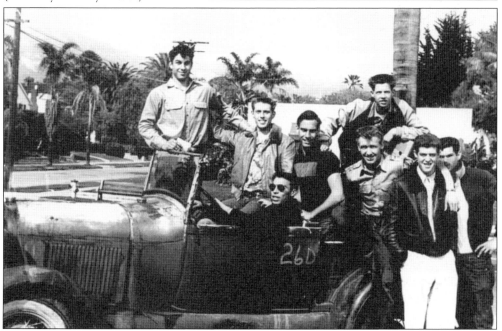

Here are three of the Igniters of Santa Barbara making an appearance at Santa Maria Drag Strip with the club's 1937 Ford sedan. Looking smart in white coveralls and snap-brimmed hats are, from left to right, Gary Henshaw, Dave Boccalli, and Tony Cavalli. (Courtesy of Barry Atsatt.)

Willis Partch of Santa Barbara seems apprehensive about the work done on Don Lanning's 1932 Ford Deuce roadster. He is pointing at an early 21-stud flathead V-8 with a single carburetor. The fenders must have been just removed, because the car still has its fender brackets (visible over front tire). The windshield has also been taken off. (Courtesy of Willis Partch.)

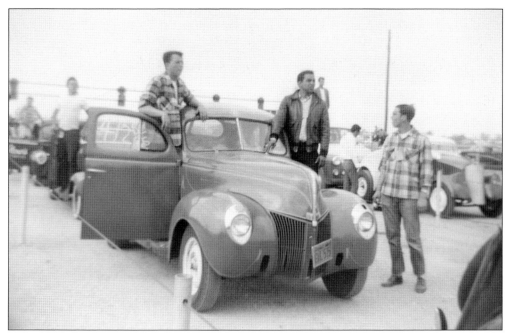

When Santa Barbara hot-rodders were not drag racing at Santa Maria, they would travel down to one of the many strips in Los Angeles or Orange Counties. Seen here waiting their turn in the qualifying line at Lyons Drag Strip are two members of the Igniters in a 1940 Ford Standard Coupe. Standing at left is Dick Hoskins, and at right in the leather jacket is Tony Cavalli. (Courtesy of Willis Partch.)

Santa Barbara High School class of 1953 graduate Frank Viera is seen with his 1922 Ford Model T touring car. Touring cars, or "tubs," could be made into some pretty cool-looking rods, as seen here. The hot rod was powered by a four-cylinder Ford C block with a rare Alexander overhead conversion and a twin Zenith carburetor setup. (Courtesy of Frank Viera.)

Here is another view of Frank Viera's Phaeton, this time at a 1958 Santa Barbara High School car show at Peabody Stadium. The Alexander overhead conversion can be seen to a better advantage here. Legendary hot rod builder Sam Foose did some of the bodywork on the canary yellow touring car. This big tub could be filled up with friends for Saturday-night cruising, or driven up to Santa Maria for the drags. (Courtesy of Jack Chard.)

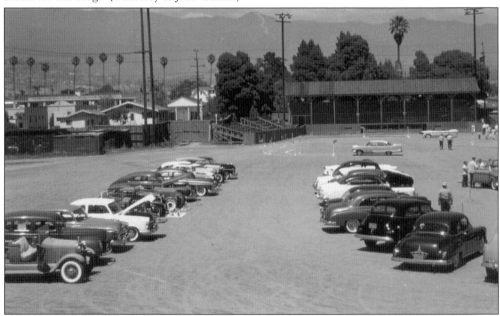

In 1957, Santa Barbara High School, along with the Dusters car club, held a car show at Pershing Park, located at the west end of Castillo Street by Santa Barbara City College. A Model A pickup, 1940 Ford sedan, and Oldsmobile Rocket 88 are included in the line of cars in this image. In the background, a big, new Dodge or Plymouth is negotiating the Safety Jamboree test course. (Courtesy of Jack Chard.)

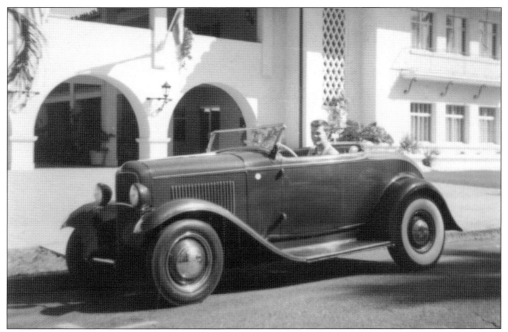

Willard Partch sits in Don Lanning's 1932 Ford roadster, parked in front of the newly completed Santa Barbara Courthouse Annex on Figueroa Street in 1954. The maroon, full-fendered Deuce was powered by its original flathead V-8 equipped with Edlebrock heads and manifold and a Collins camshaft. (Courtesy of Don Lanning.)

Although Stewart-Warner kits or Auburn dash inserts were popular alternatives to the stock dashboards in hot rods, it was not unusual to see complete dashboard assemblies from other cars grafted to the rod's interior. Don Lanning's 1932 Deuce roadster was equipped with this neatly installed 1940 Ford unit. (Courtesy of Don Lanning.)

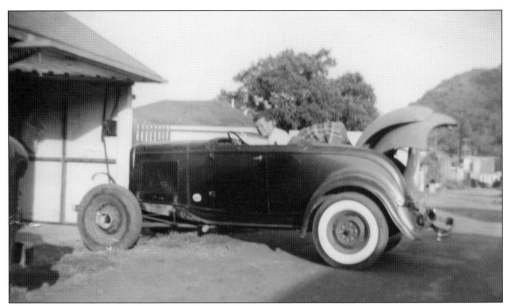

Don Lanning is seen here sitting in his newly acquired Deuce roadster, parked in the driveway of a rented garage in Santa Barbara's west side (that is the foot of Television Hill in the right background). Don would go on to a successful career teaching shop class and coaching football at his alma mater (class of 1955), Santa Barbara High School. (Courtesy of Don Lanning.)

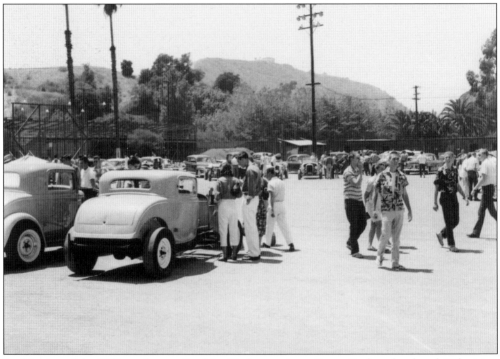

In this view of the 1957 car show at Pershing Park, prominent Santa Barbara landmark Television Hill stands out in the background. Visible at the top of the hill are the newly completed studios of local station KEYT-TV. The coupe in the left foreground belongs to Dusters charter member and future Bonneville record holder Fred Dannenfelzer. (Courtesy of Jack Chard.)

Three

GOLETA

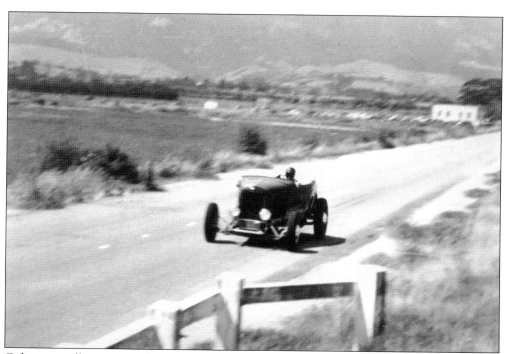

Goleta, a small town six miles north of Santa Barbara, was mainly known as the location of the small local airport. After the airfield's wartime service as a Marine air station, a group of local hot-rodders formed an "acceleration association" and made part of the airport into America's first drag strip. In this image, an unidentified roadster nears the livestock crossing over Carneros Creek that served as the finish line. (Courtesy of Don Lanning.)

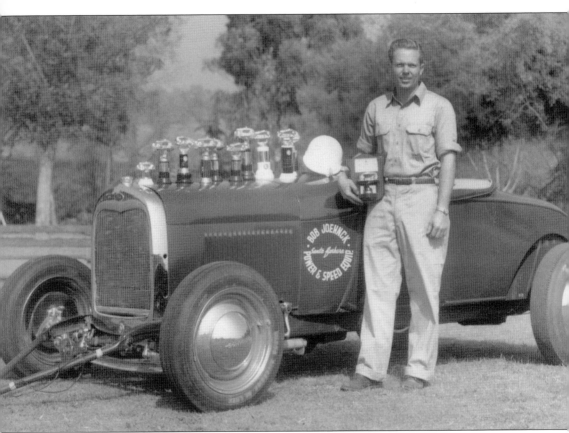

If anyone were rightfully to be called the godfather of drag racing, it would be Bob Joehnck, pictured here with his deep red 1929 Ford roadster. A Santa Barbara native, Bob was the motivating factor in the establishment of the first drag strip at Goleta. He founded the Santa Barbara Acceleration Association and was instrumental in acquiring the insurance and other documentation necessary to start the first legal drag-racing operation in the country. Joehnck was also well known as an engine builder and producer of speed equipment, building engines like the Ardun-Mercury overhead V-8 in Motor Monarch Dave Marquez's famous roadster, "No. 880." Bob's business, Bob Joehnck Automotive, is still a part of the Santa Barbara hot rod scene. (Courtesy of Don Lanning.)

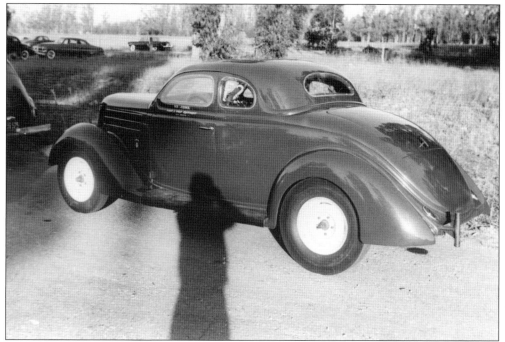

Among the many hot rods owned and raced by Joehnck was this chopped 1936 Ford five-window coupe, which had quite a history. Originally built by Los Angeles hot-rodder Tom Cobb as a lake racer, it was then sold to Joehnck. Joehnck raced it for a while, and then the rod went through a series of local owners, including Jerry Gaskill. The fully modified dragster was sold to an Oregon resident who then downgraded it into a street rod, which survives today. (Courtesy of Don Lanning.)

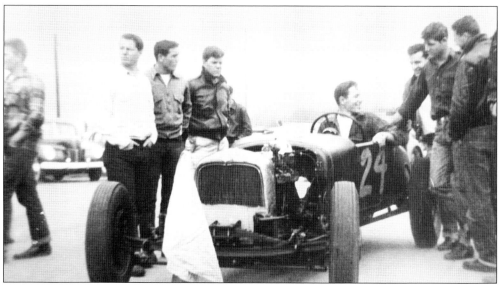

Among the earliest hot-rodders to race at Goleta was Keith Loomis of Ojai, seen here at Goleta in 1949. Keith is seated behind the wheel of his modified 1927 Ford T roadster. It was powered by a mid-1940s Chevrolet six with a Wayne 12-port head and Winfield carburetors, a departure from the usual Ford-powered machines. (Courtesy of Keith Loomis.)

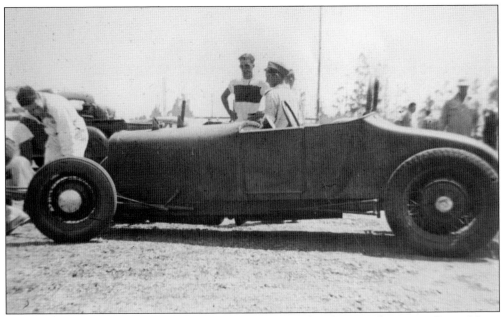

The clean lines of Keith Loomis's roadster are really evident here in the pits at Santa Maria Fairgrounds in 1949. That is a 1932 Ford grill shell up front. On the day this picture was taken, several cars were wrecked, and a driver, killed during a race on the old horse track at the fairground, a dangerous, old, half-mile dirt oval. Loomis is at left unhooking the tow-hitch, and Howard Hall of Ojai is at center in the sunglasses. (Courtesy of Keith Loomis.)

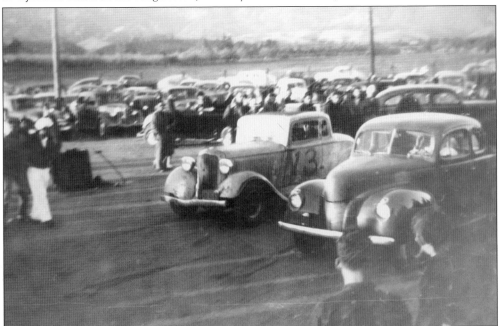

Keith Purrington, at left in his 1934 Plymouth five-window coupe, is pictured at the Goleta starting line about to take on a 1940 Ford coupe from the Los Angeles area. The number 13 on the side of Keith's hot rod would prove to be bad luck, because he would soon wreck it. He did salvage the engine for use in another rod. (Courtesy of Lee Hammock.)

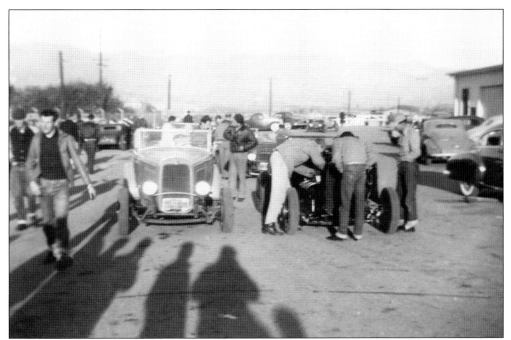

This image really captures the atmosphere of a cold late afternoon in the pit area of Goleta. At left sits a 1931 Ford roadster, while on the right, a group of hot-rodders pitches in to solve some mechanical problem. In the background are the Los Padres Mountains. (Courtesy of Lee Hammock.)

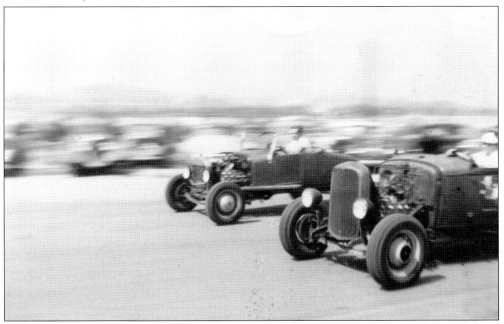

Bob Hays of Santa Barbara streaks down the strip at Goleta in his flathead powered 1927 Model T roadster in a race against an unidentified opponent from Los Angeles. The other roadster appears to be a fairly rare 1933 Ford with what looks like cartoon character Donald Duck painted on the door. (Courtesy of Lee Hammock.)

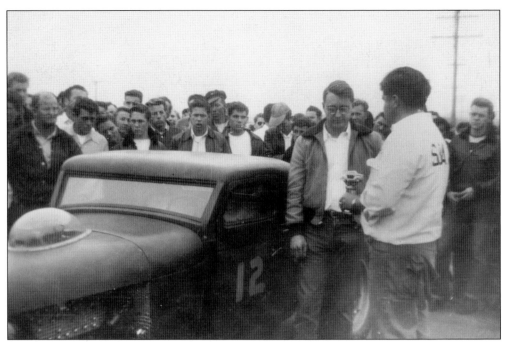

Tom Cobb, a well-known hot-rodder from Santa Monica, is awarded a trophy from SBAA president Stoddard Hensling at an early Goleta meet. The blown 24-stud flathead had an aircraft carburetor under that Plexiglas bubble on the hood. Note the rather sullen-looking crowd of leather-jacketed youths in the background. (Courtesy of Lee Hammock.)

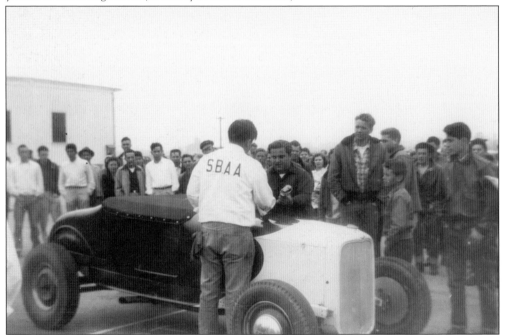

Stoddard Hensling awards a trophy for best time of the day to the owner of this smart-looking Ford Model T roadster. Note the scalloped paint job and the Deuce grill shell. The car is sitting exactly across the drag strip starting line. (Courtesy of Lee Hammock.)

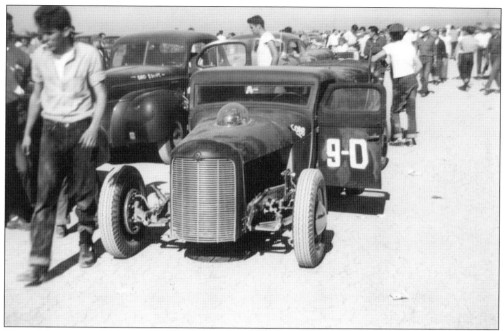

Santa Monica resident Tom Cobb ran this cool rod, seen here at Goleta Drag Strip. Under the Plexiglas bubble on the hood is a flathead V-8 equipped with an aircraft supercharger. The grill shell came from a 1932 DeSoto. The metal roof could be removed, so the rod could be raced in either coupe or roadster classes. (Courtesy of Lee Hammock.)

This somewhat blurred image shows the one time that drag racing was allowed on the actual runway at Santa Barbara Airport. The Firestone Road strip had to be closed for maintenance, and the airport authority gave permission to the SBAA to hold this one-day event. (Courtesy of Lee Hammock.)

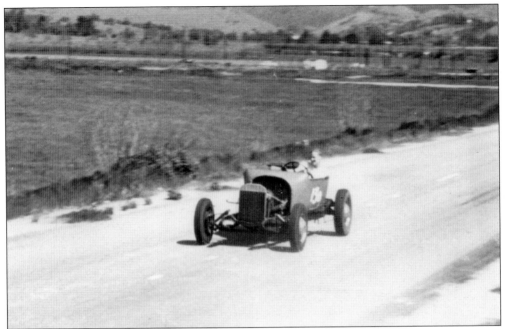

John Purrington of Santa Barbara runs his Plymouth-powered Ford roadster down the strip at Goleta. Note the absence of the radiator shell and, of course, any safety gear. Surprisingly, there were never any serious accidents or injuries the entire time the SBAA held drag races at the Goleta location. (Courtesy of Lee Hammock.)

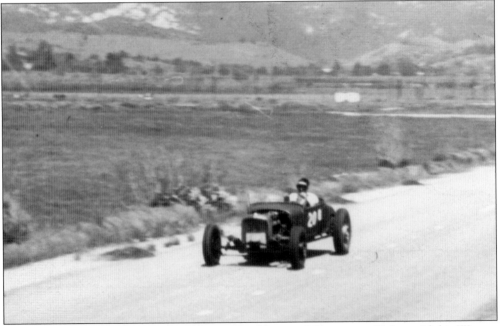

When he was not racing jalopies, Keith Loomis of Ojai could be seen at Goleta with his Wayne-Chevrolet–powered 1927 T-bucket. The view of the foothills in the background is today obscured by development and Highway 101. In 1949, the area surrounding the drag strip was all farmland and tidal swamp. (Courtesy of Lee Hammock.)

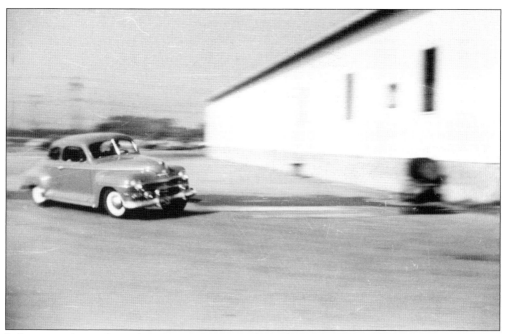

Lake racers, hot rods, and sports cars were not the only types seen on the track at Goleta. Bob Postell of Santa Barbara is pictured here taking his parents' almost-new 1948 Plymouth around the warehouse. He actually got it up on two wheels during this turn. Fortunately, he got it back down again. (Courtesy of Lee Hammock.)

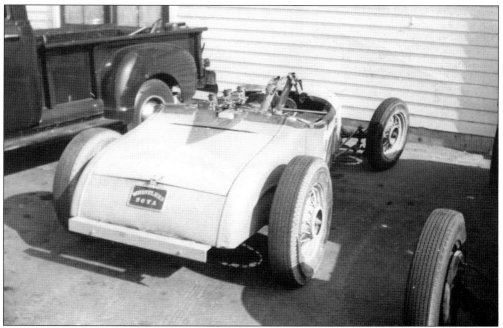

This is Monte Hendricks's Tombstone Special. Built by Rip Erickson as a front-engine rod at his garage on Milpas Street across from the Hendricks family funeral-supply business, this rear-engined version was powered by a 1947 Chevrolet straight-six equipped with a Wayne head and manifold and three Stromberg carburetors. It was later sold to Keith Loomis. (Courtesy of Lee Hammock.)

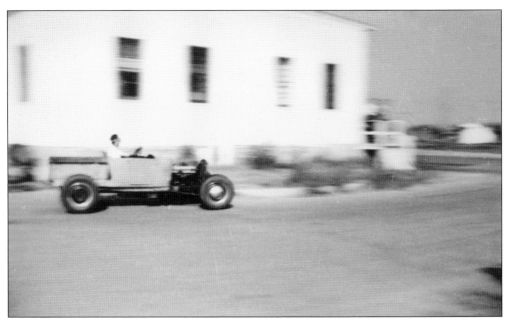

Another Santa Barbara local, Toby Schwalenberg, is seen here hauling his Chevy-powered Model T roadster pickup around the warehouse track at Goleta. The SBAA established the rough figure-eight course for when drivers got tired of racing in a straight line. This building and many others seen in these images are still in existence today. (Courtesy of Lee Hammock.)

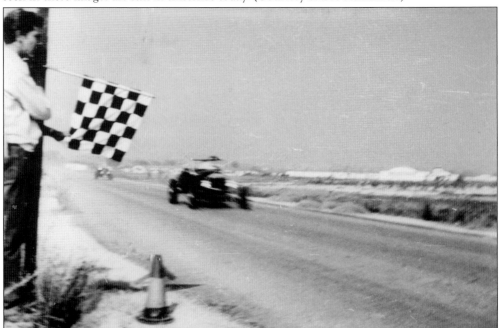

At the finish line at Goleta, SBAA flagman Dave Malis is about to drop the checkered flag on fellow SBAA member Jimmy Terres. The small bridge crossing Carneros Creek is just out of the picture, behind where the photographer is standing. Malis was connected to the improvised control tower by a hand-cranked field telephone attached to the pole at his left. (Courtesy of Lee Hammock.)

Dave Malis (left) and Lee Hammock (right), engage in a Ford-versus-Chevy duel during the summer of 1948. From the looks of it, the Ford has got the jump on things this time. In the background are some of the many vacant buildings left when the Marine Corps abandoned the air base after the war. (Courtesy of Lee Hammock.)

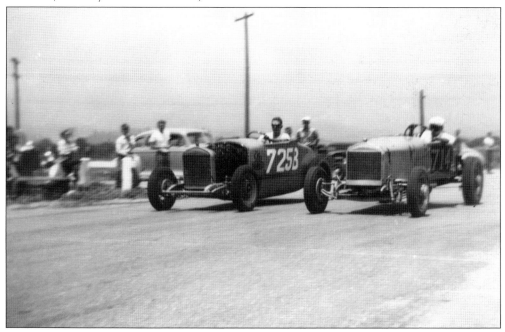

Monte Hendricks, at left, is seen at left racing Billy Byron's Model T roadster. Like many hot rods, Byron's car was made up of parts from several old junk cars. The frame came from a Chevrolet, and Lee Hammock donated the Ford body. It was powered by a Chevrolet six. (Courtesy of Lee Hammock.)

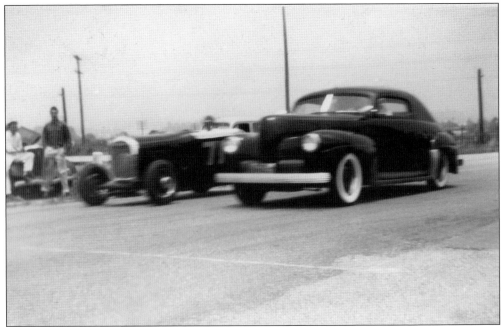

This slightly blurry picture shows SBAA founding member and engine builder Bob Joehnck, at left, about to take off in a race with Jack Quinton in his custom 1941 Ford Coupe. It looks like Jack has chopped the black custom's roof by about three inches. (Courtesy of Lee Hammock.)

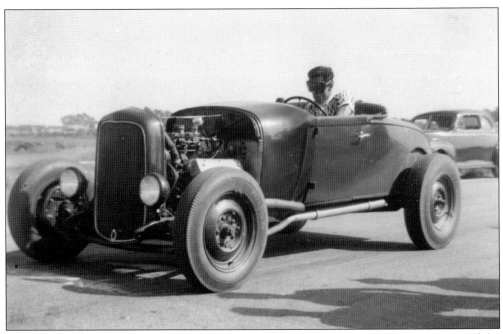

This nice-looking 1929 Ford roadster from Los Angeles showed up at Goleta during one of the early meets. The engine sports a pair of relatively rare Riley heads and an exhaust cutoff. The fit and finish look good. Note how the 1932 Ford grill shell has been dropped, and the headlights, lowered. (Courtesy of Lee Hammock.)

Another frequent visitor to Goleta in the early days was well-known hot rod builder Don Mansfield of Ojai. One of his creations, which also served as his personal rod, was this little flathead-powered Model T roadster. This was state of the art for a hot rod of the late 1940s. Note the "chopped" canvas top and chrome tube shocks. (Courtesy of Lee Hammock.)

Tom Cobb of Santa Monica appears to be admiring either the foothills of the Los Padres Mountains in the background or, more likely, the chrome louvers on the 1934 Ford behind him. This image also gives a view of his hot rod's blown AB flathead engine. The carburetor is said to have come from an aircraft engine, possibly a Ranger or Menasco. (Courtesy of Lee Hammock.)

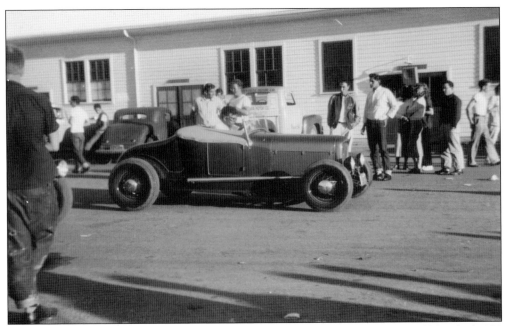

SBAA member Jimmy Terres is seen here poised at the Goleta starting line. His well-finished 1929 Ford roadster was painted metallic gold with black headlamps and wheels. Note that big chrome straight exhaust pipe. The rod was built by Terres's uncles, who owned the Fernandez Brother's Garage on Milpas Street in Santa Barbara. (Courtesy of Lee Hammock.)

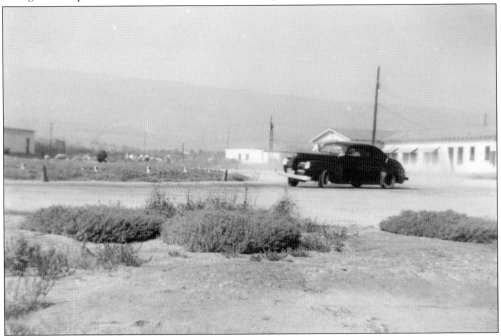

A black custom 1941 Ford driven by John "Cruiser" Quinton heels over as it turns on the SBAA's road racetrack. The rough dirt track began at the warehouse visible in the left background (north of Hollister Avenue near Robin Hill Road) and ran west in a very rough figure-eight configuration toward Carneros Creek. (Courtesy of Lee Hammock.)

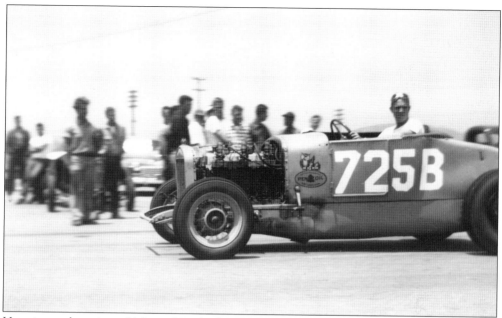

Here is another view of Monte Hendricks's 1927 Model T–bodied dragster, which shows the Chevrolet 235-cubic-inch six-cylinder engine to good advantage. This engine would shortly be installed in the rear-engine Tombstone Special. The race number on the side is from Hendricks's days racing at El Mirage Dry Lake. (Courtesy of Lee Hammock.)

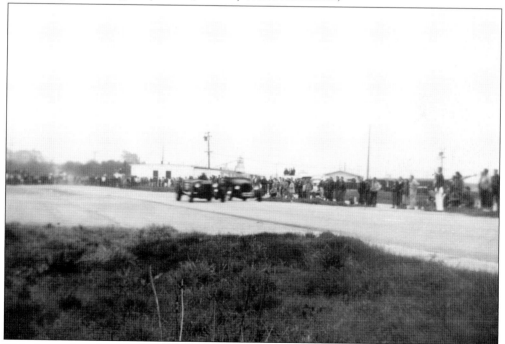

This shot, taken from midway down the strip at Goleta, shows a duel between two roadsters. Some races in those days started from a rolling start instead of a standing start because a lot of the cars were geared for long acceleration runs on the lake bed and not the relatively new sport of drag racing. (Courtesy of Lee Hammock.)

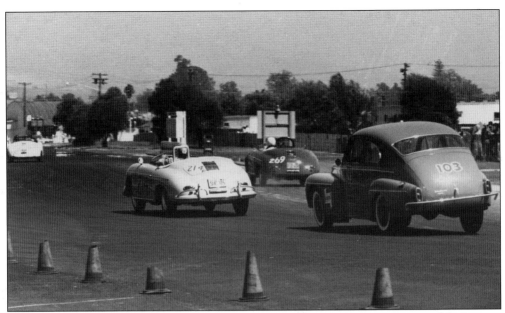

Quite a few local car club members also raced European cars at Goleta. Barry Atsatt of the Igniters is seen here at center in his light blue Porsche 356 Speedster as he has just passed a Volvo 544. Except for safety equipment, cars in Barry's class raced as factory unmodified. The field in this race appears to be mostly made up of Porsches. (Courtesy of Barry Atsatt.)

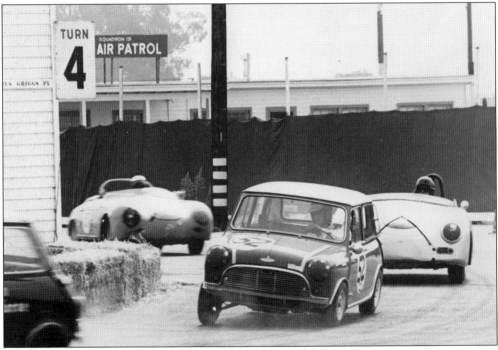

Barry Atsatt heels his Austin Mini Cooper over into Turn Four with a Porsche on his tail at Goleta during a 1966 race. The little blue-and-white Mini Cooper was powered by a stock 1275cc Austin A engine. Barry was a dealer of imported car parts in Santa Barbara and, for a short time, was also a dealer for the little-known English sports car manufacturer Elva. (Courtesy of Barry Atsatt.)

Four

THE BALDWIN SPECIALS

Willis M. "Bill" Baldwin, creator of the Baldwin Specials, was born in Santa Monica, California, in 1913 and moved to Montecito in the early 1940s. While working in the aircraft industry, he acquired a high degree of skill in metal fabrication, welding, and general mechanics. A natural engineer, he combined these skills with a great sense of style and built a series of "sports rods" that challenged and often beat the best European sports cars around at the time. (Courtesy of the Baldwin family.)

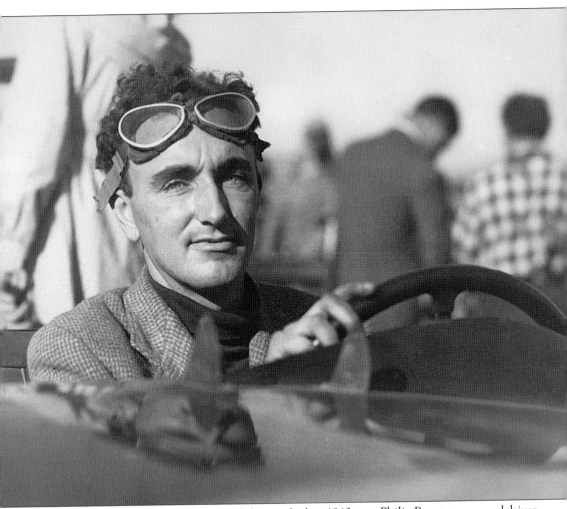

One of the most interesting figures at Goleta in the late 1940s was Philip Payne, owner and driver of the first Baldwin Special. Born in Portsmouth, England, Payne was employed during World War II as an aeromechanic by Gloster Aircraft, where he was involved in the development of one of the first fighter jets, the Gloster Meteor. After the end of the war, Payne traveled to America by ship, bringing with him his wife and a Brooklands-Riley sports car. The two proceeded to drive from New York to Los Angeles in the Brooklands, and they settled in the Laurel Canyon area of Hollywood. Philip was quickly offered a job as mechanic at International Motors in Hollywood, a dealer of British and European cars to Hollywood film stars and other celebrities. He also became part of the local hot rod scene, joining the Glendale Sidewinders, which became California Sports Car Club. (Courtesy of Stephen Payne.)

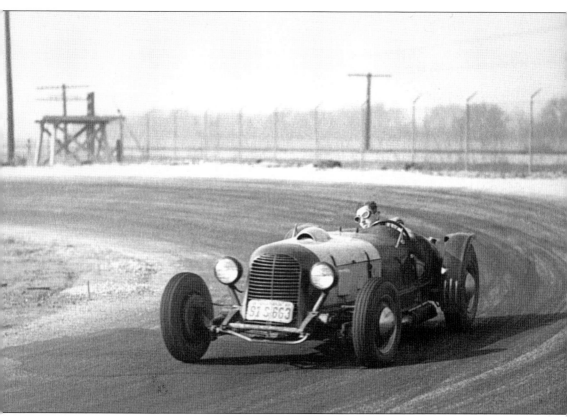

Sometime in 1947, Payne acquired the first of the specials built by Montecito resident Willis "Bill" Baldwin. He raced the sports rod successfully throughout Southern California between 1947 and 1949 before returning with it to England, where the British press and public had a hard time believing that an American hot rod could regularly attain speeds over 100 miles per hour. The Baldwin/Payne Special, as it came to be known, was run competitively in England until the early 1950s, and Payne drove it regularly until 1959, when he retired it to start a family. Payne passed away in 1981, and today, the Baldwin/Payne Special is owned by his son Stephen Payne. (Courtesy of Stephen Payne.)

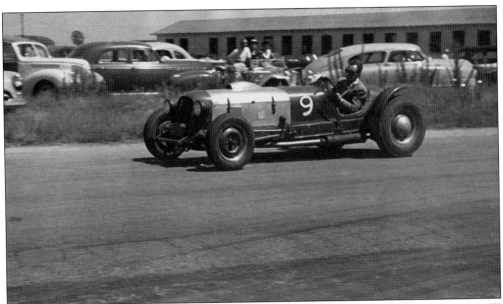

Philip Payne is seen racing at Goleta on August 7, 1949, when he took first place in the Class III CSCC timing trails. The first Baldwin was an interesting mix of British racing style and American engineering, outwardly appearing similar to cars seen racing at the famous prewar English racetrack Brooklands. This shot is looking southwest toward the airport. (Courtesy of Stephen Payne.)

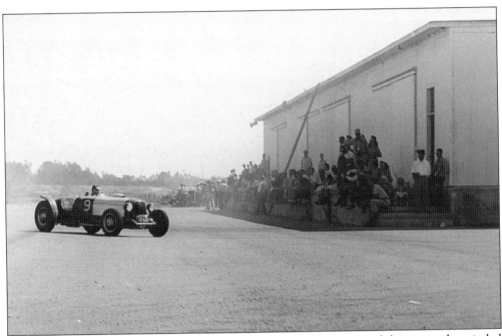

Seen here from another direction, Payne is muscling the Baldwin around the course that circled the old air base warehouse north of the drag strip starting line. Some of the early CSCC events were held here; later races would be held on a course that ran around the unused taxiway and hardstand area in the northeast corner of the airport. (Courtesy of Stephen Payne.)

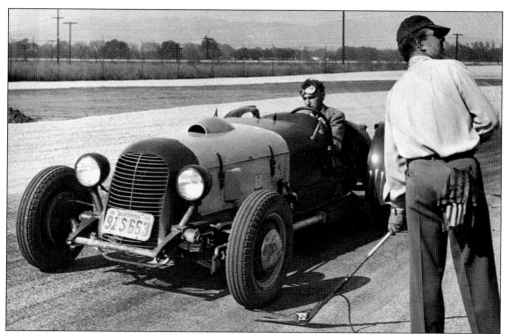

Willis Baldwin's first special used a modified 1932 Ford frame as a foundation. The center X-frame was removed and replaced by tubular cross members. The engine was moved 15 inches to the rear and lowered for better balance, and the suspension was improved. Instead of a Ford roadster body, the radiator shell and cockpit were fabricated from pieces of an old Dodge body shell. The hood was aluminum sheet. The air scoop visible on the hood was salvaged from a jet airplane, and the radiator grill was made up of welding rod. (Courtesy of Stephen Payne.)

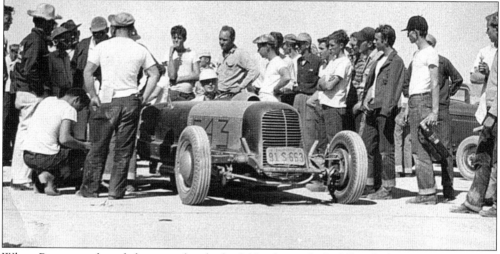

When Payne purchased the special, it had a 346-cubic-inch Cadillac flathead V-8. He quickly replaced that engine with a Mercury AB block of 249 cubic inches and equipped with an Isky camshaft, Evans heads, and a tri-carburetor setup, producing 175 horsepower at 5,000 revolutions per minute. Power was transferred via a lightened flywheel, 10-inch Mercury clutch, and Ford three-speed transmission to a 3.78:1 rear end. The Baldwin, with Payne at the wheel, is seen here at El Mirage Dry Lake for a CSCC/Russetta timing meet on October 10 1948, in which it did a quarter mile in 8.8 seconds, reaching 102.27 miles per hour. (Courtesy of Stephen Payne.)

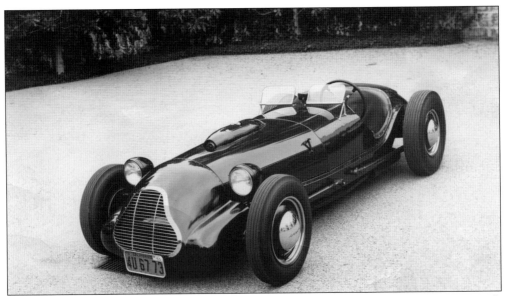

Baldwin's second special, commonly called the Baldwin/Mercury, and was built over a 12-month period in 1948–1949. It was based on a wrecked 1946 Ford Tudor; Baldwin discarded the Ford's body and started with a clean slate. The result was this roadster, similar in appearance to an Indianapolis racer, or even more so to the Allard J2. (Courtesy of Lee Hammock.)

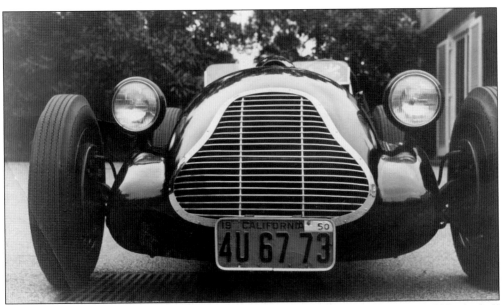

In similar fashion to the first car, the nose of the Mercury Special was made up of old body shell parts, in this case Plymouth. Baldwin fashioned the radiator grill out of an old refrigerator shelf, carrying on his philosophy of using as much recycled material as possible. The rear body used Chrysler fender sections in its construction. (Courtesy of Lee Hammock.)

This shot shows the stepped-radiator arrangement on the special. In order to clear the low-profile body, Baldwin cut the radiator in two and placed the lower section about a foot forward of the top. He intended to put a Rootes blower in the space between. The front suspension was stock Ford. (Courtesy of Lee Hammock.)

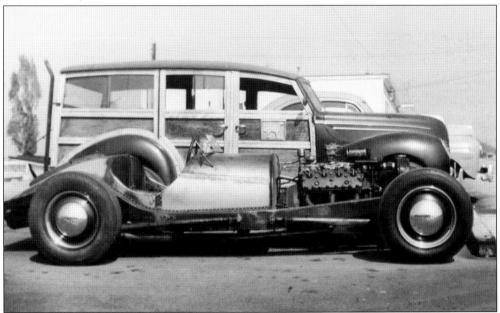

This shot was taken in the parking lot at Goleta in 1949 during the unfinished special's testing. The frame was shortened by 14 inches, and as with the Baldwin/Payne, the X-frame was removed and replaced by tubular cross members. The only modification to the suspension was the decambering of the rear transverse springs in order to compensate for the much lighter load the car was carrying. (Courtesy of Lee Hammock.)

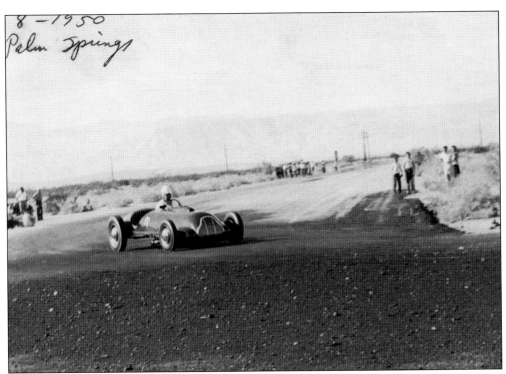

8 — 1950
Palm Springs

After the special's completion, the first race it competed in was the SCCA meet at Palm Springs, California, in April 1950. Seen here with Lee Hammock at the wheel, the car was obviously faster and better handling than the competition, but it was plagued with distributor problems and failed to finish. (Courtesy of Lee Hammock.)

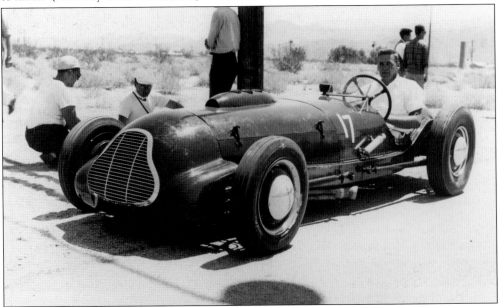

Here is Lee Hammock in the Baldwin/Mercury at Palm Springs. This shot shows the red special's bodywork to good advantage. The hood scoop was made from an old bullet headlamp lengthened with a straight section and covering the generator and carburetors. (Courtesy of Lee Hammock.)

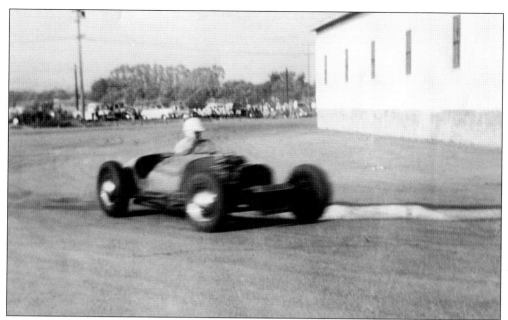

Here, the Baldwin/Mercury is blasting around the warehouse at Goleta while being tested by Lee Hammock. The original engine was a bored and stroked 284-cubic-inch Mercury 59A block equipped with a full-race camshaft, plus Offenhauser heads, manifold, and a triple-carburetor setup. It was hooked up to stock Ford transmission, shortened torque-tube, and 3.78:1 rear end. (Courtesy of Lee Hammock.)

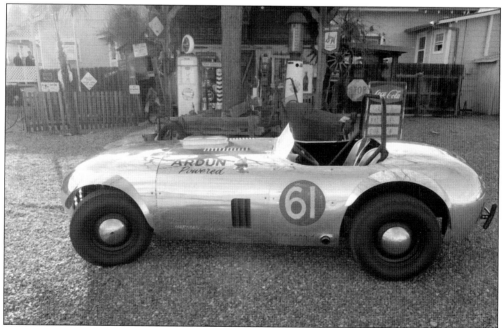

The third Baldwin special, built in 1951, was closer to an Indianapolis Speedway racer in appearance. Following the formula of the second car by using a modified 1947 Ford Tudor frame with stock suspension and a Mercury flathead, Baldwin used his experience as an aviation engineer to fabricate this modernistic aluminum body. (Courtesy of Stu Hanssen.)

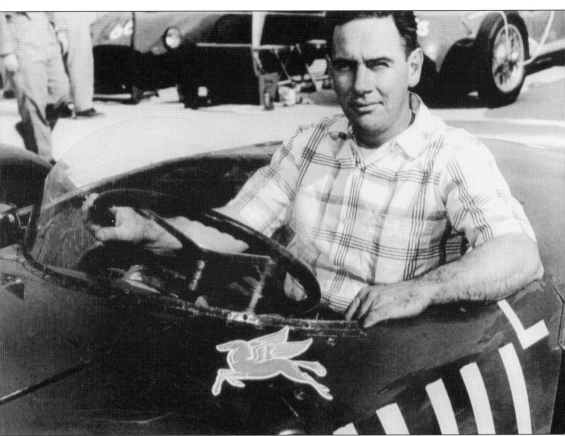

In 1954, the third special was sold to Bill Hannsen, the manager of the Walora Ranch in Goleta. Hannsen was an avid sportsman, counting road racing among his many hobbies. After racing a Jaguar XK 120 coupe in the early 1950s, Hanssen purchased the special from Baldwin friend Don Balch. Hannsen raced the special throughout the mid-1950s. In 1956, he was racing at Pebble Beach when his friend and fellow competitor Ernie McAffee was killed driving a Ferrari. Hanssen quit racing after that, and the special was sold a few years later. (Courtesy of Stu Hannsen.)

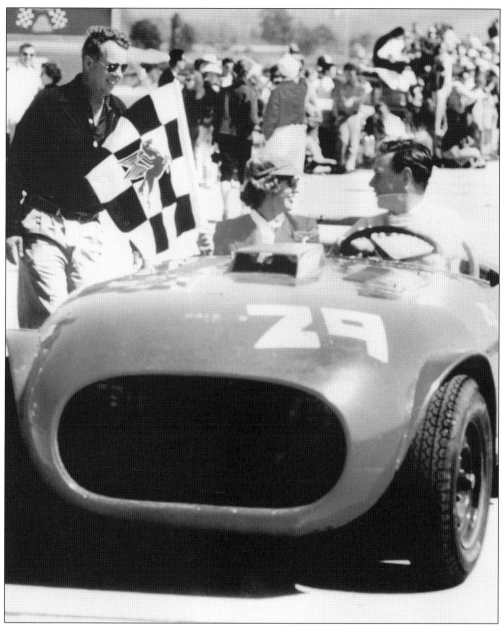

Hannsen is pictured here after having won a March 1956 SCCA meet at Goleta. His wife, Doodie, is sitting to his left, and Clarke Hall is at far left, holding the flag. The third special was sold in the late 1950s, and not much is known of its history until it was discovered on the streets of Los Angeles in the 1970s by automotive artist Baron Margo. It has been restored and is now owned by Hannsen's son, race car driver Stu Hannsen. (Courtesy of Stu Hannsen.)

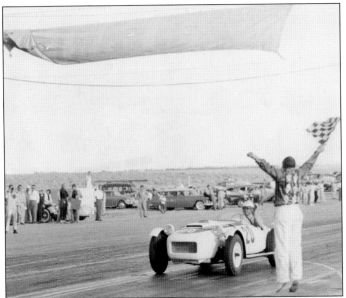

The last of the Baldwin specials was a departure from the way Willis Baldwin had been making race cars. Instead of being constructed of a salvaged Ford chassis, the frame was built up from three-inch exhaust tube stock. Some Ford parts were used in the suspension, and as before, Baldwin powered it with a Mercury flathead and cooled it with a dual-core radiator. The body shell was a fiberglass kit Bangert "Stag" roadster body by Hollywood Plastics. (Courtesy of the Simpson family.)

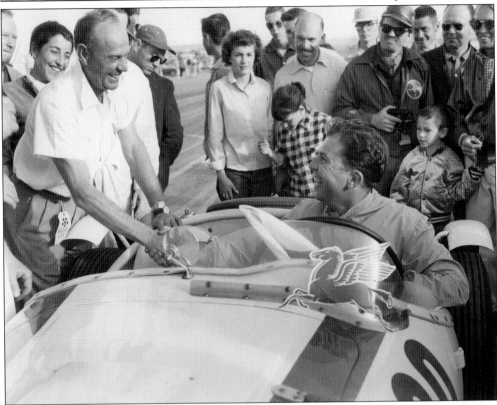

Known as the Baldwin Mark ll Special, it was sold to prominent Santa Barbara resident Ken Simpson. Simpson, using pioneer California road racer Bill Pollack as driver, would race the special at meets all over California, including Santa Barbara, Palm Springs, and Willow Springs. Its current whereabouts are unknown. In this image, owner Simpson shakes Pollack's hand after a victory at Willow Springs. (Courtesy of the Simpson family.)

Five

BUELLTON AND LOMPOC

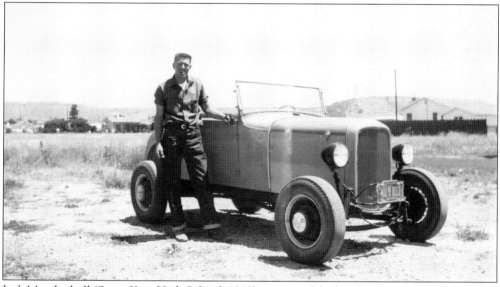

Jack Mendenhall (Santa Ynez High School, 1948) was one of the best-known and -liked figures of the Central Coast hot rod scene. A Santa Ynez Valley native, Jack owned and operated gasoline stations and tow services in Buellton for over 25 years. During that time, he was building and racing hot rods, dragsters, jalopy racers, lake racers, and off-road racing vehicles. Jack is pictured here around 1955 with his personal car, a clean and simple primer-gray 1931 Ford Model A roadster sporting the ever-popular 1932 grill shell. In contrast to some of the more elaborate hot rods that were being built by then, this unchanneled rod was more like those seen on the street 10 years earlier. The foothills in the background are a part of the J-Bar-E Ranch of Buellton. (Courtesy of Mark Mendenhall.)

Here, 16-year-old Jack Mendenhall poses behind the wheel of his first car, a roofless 1934 Ford coupe. Besides the roof being cut off, the fenders and hood have been removed. However, it looks like that is as far as Mendenhall got in this image from 1947. (Courtesy of Mark Mendenhall.)

This dragster was built by Mendenhall and sponsored by Andersen's Restaurant. Andersen's, world famous for its split pea soup, was (and still is) a landmark to all drivers traveling on Highway 101 up and down the Central Coast. Wearing their pea-green crew jackets are Jack Mendenhall (right), Butch Dixon (left), and an unidentified mechanic. (Courtesy of Mark Mendenhall.)

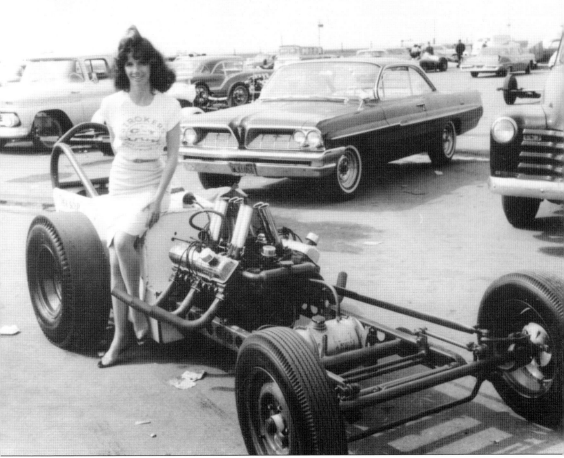

The Anderson's *Pea Soup Special* ran originally as a flathead-powered gasser, and like most dragsters, it went through a variety of engine changes. In this image from around 1960, it is powered by a fuel-injected Cadillac. Mendenhall had a close relationship with the Anderson family and they sponsored some of his race cars. One member of the family, Robbie Anderson, was a member of Mendenhall's pit crew. This early dragster has survived and is on display at the Mendenhall Museum in Buellton, a large collection of vintage automobilia located at Jack Mendenhall's former tow-yard, and run by his son, Mark. (Courtesy of Mark Mendenhall.)

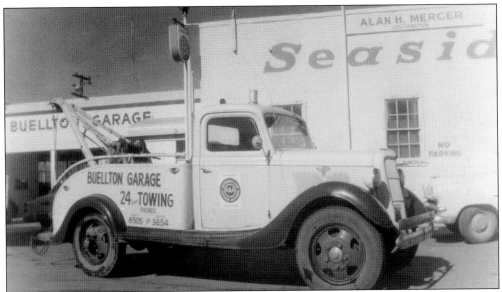

Buellton was the only stop on the highway for miles around that offered automotive service, and breakdowns and accidents were common occurrences. Mendenhall's Buellton Garage used this 1936 Ford tow truck to rescue stranded motorists. The "Seaside"-labeled building in the background is a bulk facility that serviced the fuel and oil needs of local ranches. (Courtesy of Mark Mendenhall.)

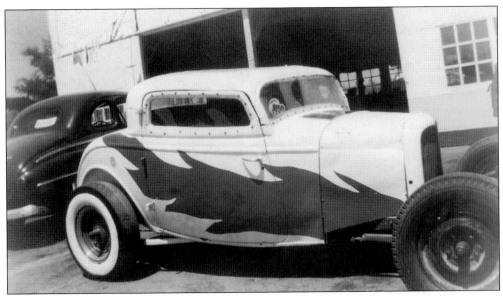

This is another one of Jack Mendenhall's drag racers. The white-and-red chopped coupe was built to race at local strips like Santa Maria and San Luis Obispo. Jack, a member of the Santa Maria Dragons car club, has moved the rod's flathead engine back in the frame for better balance. Mendenhall was considered a specialist on Ford flatheads. (Courtesy of Mark Mendenhall.)

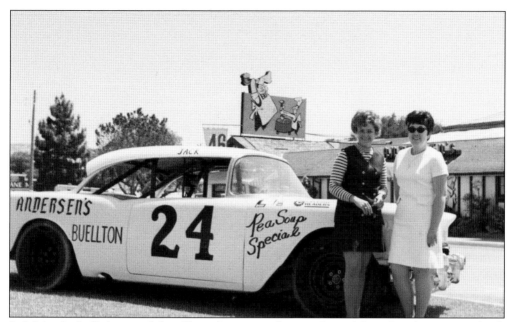

Jack Mendenhall also raced this Chevrolet as a stock car at Santa Maria Speedway, a one-third-mile dirt oval just off Highway 101 near Santa Maria. In the background is the billboard over Andersen's that depicts the restaurant's logo: a pair cartoon chefs splitting peas with a mallet and chisel. Posing for the camera are Buellton residents Joanne Heckart (left) and Judy Peters. (Courtesy of Mark Mendenhall.)

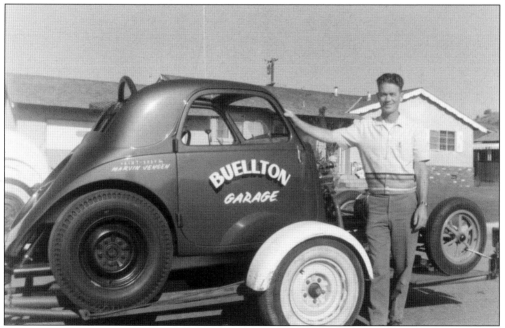

When G-class dragsters became popular in the early 1960s, Jack Mendenhall built this pretty little metallic-blue Fiat Topolino gasser. Standing to the car's right is Roy Robinson, who was Mendenhall's friend and driver. Robinson was a veteran racer who competed at strips like Long Beach and Santa Maria. (Courtesy of Mark Mendenhall.)

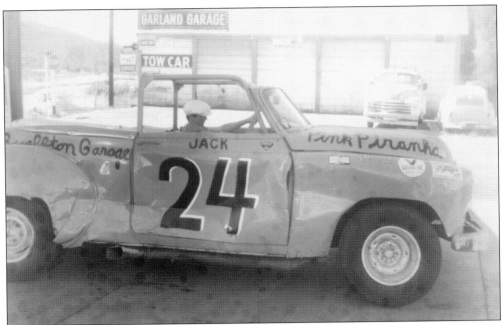

Mendenhall raced the Pink Piranha as a dirt-track car in the 1960s. The Chevrolet convertible was an Ascot Park veteran brought up from Los Angeles. In the background is Mendenhall's competitor for tow truck business, the Garland Garage. At left are Highway 101 and the start of the Gaviota Pass, in a view looking southbound to Santa Barbara. (Courtesy of Mark Mendenhall.)

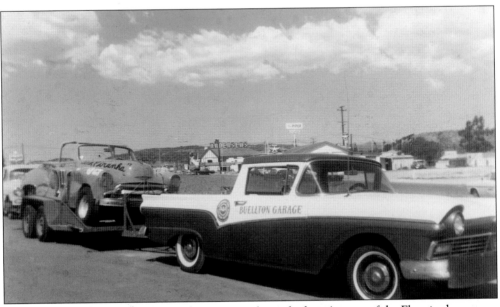

Here is Jack Mendenhall's Pink Piranha on its trailer parked on Avenue of the Flags in downtown Buellton, ready for a day of racing at Santa Maria, with Andersen's Pea Soup Restaurant in the background. Note the heavy push bumper on the Buellton Garage's 1957 Ranchero pickup. (Courtesy of Mark Mendenhall.)

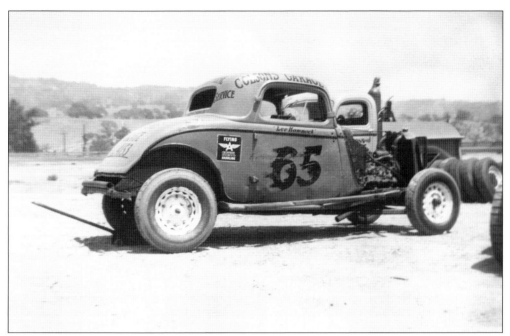

Lee Hammock was a visitor at Buellton during the late 1940s, driving the Colson's Garage 1934 Ford coupe. Although painted yellow, the coupe looks darker. The old orthochromatic black-and-white camera film used to take this image made certain colors, like yellow, appear much darker than they actually were. (Courtesy of Lee Hammock.)

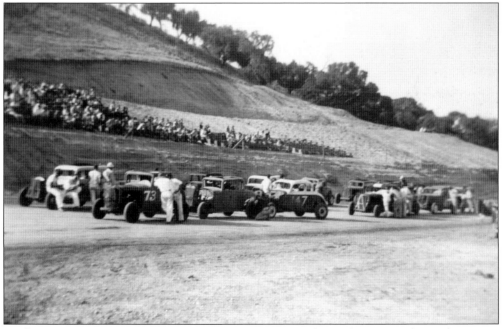

Buellton had an oval dirt track about a mile north of town by Highway 101. The track was in a natural depression in the land beneath a slope. This is the starting line. Note how the grandstands are located in a rough terrace that has been bulldozed out of the hill. People would also park on nearby ridges and watch the races from there. (Courtesy of Lee Hammock.)

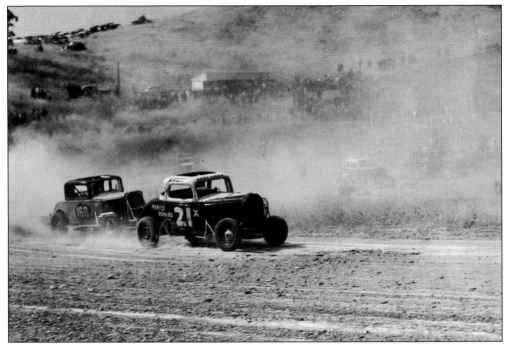

Seen coming around the bend at Buellton is Montecito's Lee Hammock, driving the Peri's Garage jalopy. Note the spectator's cars parked up on the ridge at upper left and the building visible in the center background, which served as a concession stand. (Courtesy of Lee Hammock.)

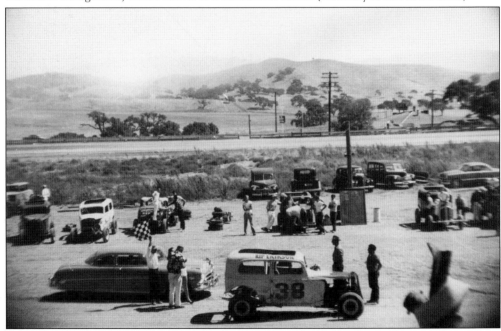

This shot, looking down on the pit area from the grandstands, shows Lee Hammock (next to the flagman) being rewarded by Buellton's trophy girl for winning yet another race. He was driving the 1934 Ford Tudor belonging to his friend and fellow driver Rip Erickson of Santa Barbara. In the background are the rolling hills of the Santa Inez Valley. (Courtesy of Lee Hammock.)

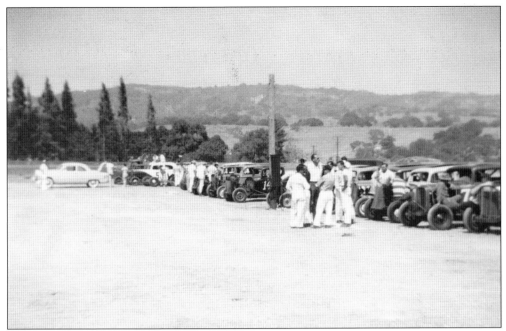

Here is the pit area at Buellton Speedway around high noon on a race day. This view is looking east with Highway 101 in the background. The long line up of competitors appears to be mostly 1934 Fords, although the car in the center, behind the pole, might be a Chevrolet. Note the 1949 Ford coupe at left. (Courtesy of Lee Hammock.)

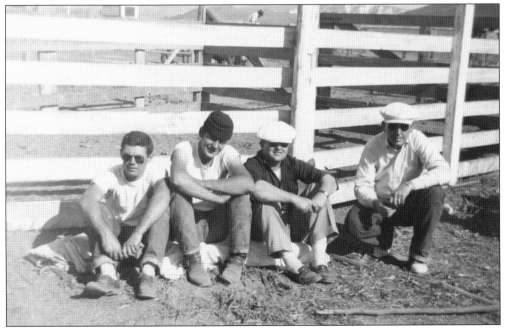

The old Lompoc fairgrounds, located southwest of town in the Beattie Park area, had a rodeo ground that doubled as a somewhat dangerous half-mile dirt track. This image from 1947 shows a very youthful group of visitors from south county. They are, from left to right, Harold Hadley, Lee Hammock, Stoddard Hensling, and Jack Quinton. (Courtesy of Lee Hammock.)

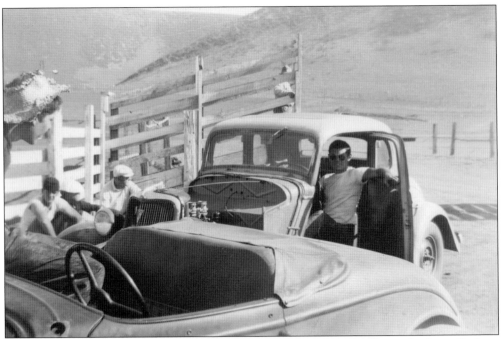

Harold Hadley of Santa Barbara is hanging out in his 1934 Ford coupe during the Santa Barbara group's visit to Lompoc. That is Fielding Lewis at far left in the straw hat. Note the cattle chute in the background. (Courtesy of Lee Hammock.)

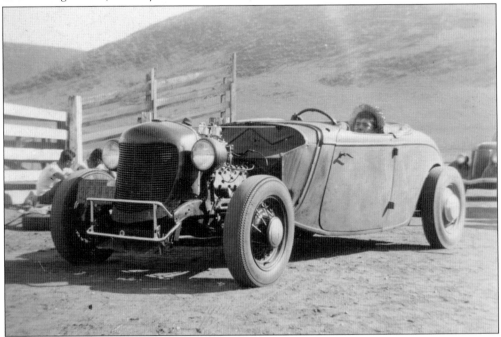

Fielding "Mouse" Lewis slouches behind the wheel of a very interesting set of wheels. This vehicle built by Willis Baldwin when he first moved to Montecito and was used as his personal car. It is a channeled, flathead-powered 1934 Ford roadster with a DeSoto grill shell. Baldwin's neighbor Lee Hammock drove it to Lompoc for the race meet. (Courtesy of Lee Hammock.)

Six

SANTA MARIA

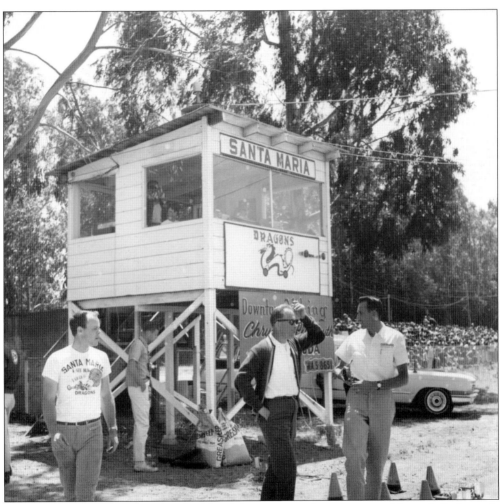

Santa Maria Drag Strip was the third legal drag strip in the country and hosted all the early greats of drag racing, as well as car clubs from all over California. Started in 1953 by Santa Maria Dragons member and local businessman Jerry Gaskill, it lasted until the mid-1960s and became a second home to many a hot-rodder. The center of all the action was the control tower, seen here on a busy race day. Jerry Gaskill is probably up in the tower directing the action as various track officials mill around in the foreground. The timing lights can be seen at lower right. This image was taken in the early 1960s, judging from the ambulance visible in the background. (Courtesy of Mark Mendenhall.)

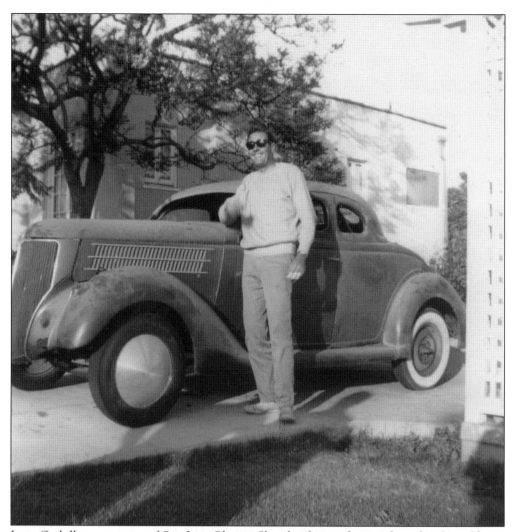

Jerry Gaskill was a native of San Luis Obispo. Shortly after graduating from San Luis Obispo High School in 1949, he acquired a Richfield service station and ran it until 1951, when he partnered with Jack Hathaway in an auto-parts store. Always an avid hot-rodder, Jerry was a regular competitor at Goleta until the strip stopped operating in 1951. With nowhere to race locally, and facing a long drive to the nearest strip in Santa Ana, Jerry looked for alternative locations to race. Settling first on Santa Maria, and later, San Luis Obispo, Jerry would run both strips successfully and also field his own dragster, occasionally taking on visiting celebrities like Tony Nancy. Gaskill eventually left the world of drag racing to become a sales representative for the Monroe Shock Absorber Company, covering California and Hawaii until his retirement. (Courtesy of Jerry Gaskill.)

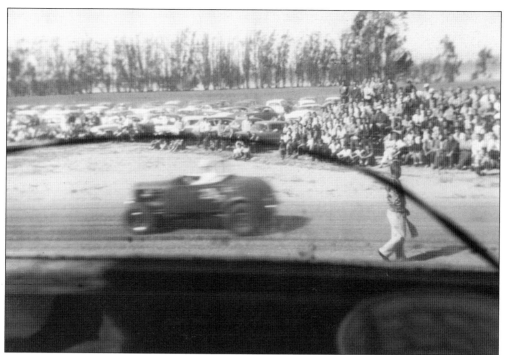

This is the view Jerry had from the tower. A roadster has just left the starting line, and flagman Don Doeckle can be seen stepping forward after doing his job. The tower is facing north, looking out across what is now Foster Road toward the airport runway, one mile distant beyond the trees. The bleachers at right are gone, but the area is basically unchanged. (Courtesy of Mark Mendenhall.)

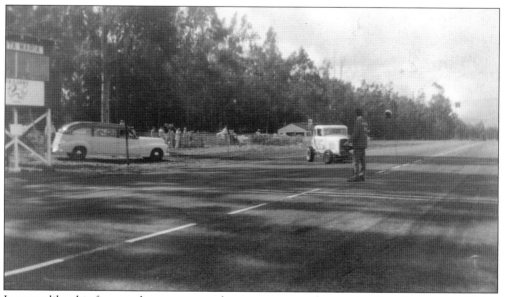

It seems like this five-window coupe may have spun out at the starting line during a qualifying run. Santa Maria Drag Strip flagman Don Doeckle may be deciding to get out of the way. Note the vintage ambulance at left. It is interesting to see that the drag strip used both starting lights and a flagman, as captured in this shot from around 1954. (Courtesy of Mark Mendenhall.)

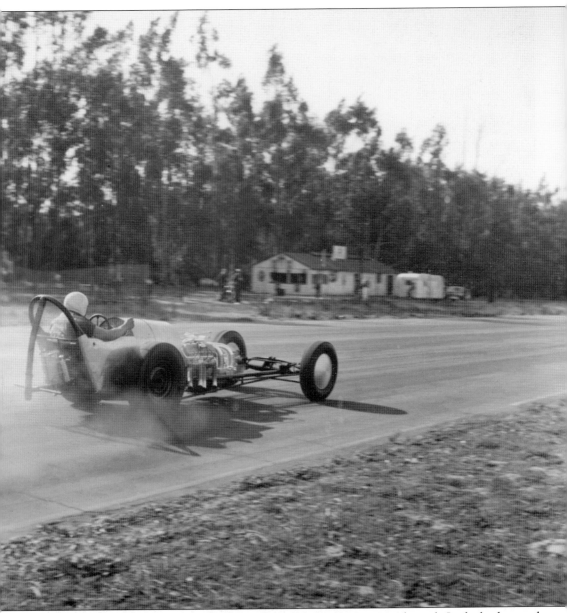

In this shot from the late 1950s, a dragster takes off down the quarter-mile track. In the background are the eucalyptus trees that make images of Santa Maria so easily identifiable. The building visible in the center background is the combination snack bar and Dragons clubhouse. In the days when the drag strip was part of an air base, the clubhouse served as a squadron dayroom. (Courtesy of Mark Mendenhall.)

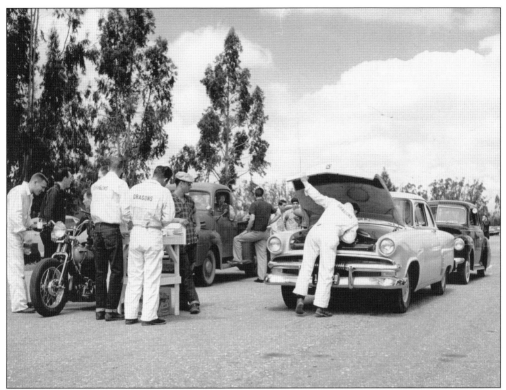

In the California tradition of "run what ya brung," almost any type of vehicle could be seen on an average race day at Santa Maria. Visible in this shot of the safety-inspection line are a Harley-Davidson (far left), a 1941 Ford pickup that was probably used for towing, a 1956 Ford, and behind that, a hoodless 1941 Chevrolet. (Courtesy of Mark Mendenhall.)

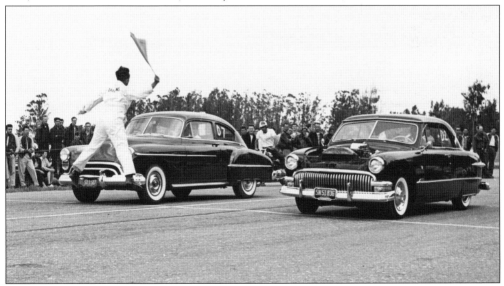

Two-door sedans duel as the flagman becomes airborne during the start of a race at Santa Maria in the late 1950s. At left is a stock-appearing 1949 Oldsmobile 98, while at right is a pretty wild-looking custom shoebox Ford with a 1947 Buick grill. (Courtesy of Mark Mendenhall.)

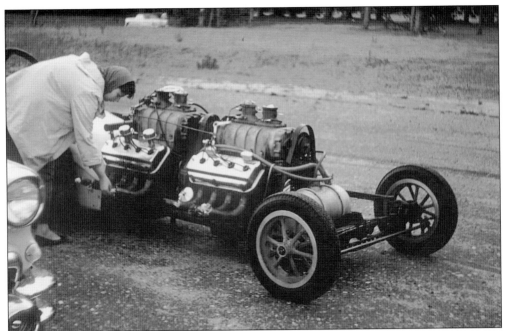

Twin-engined dragsters were crowd-pleasing attractions at races of the late 1950s and early 1960s and were run by such notables as Art Arfuns, Tony Nancy, and Tommy Ivo. Central Coast local Fred Dannenfelzer built this one, seen here on a cold day at Santa Maria, using a pair of blown Chrysler Hemi engines. (Courtesy of Fred Dannenfelzer.)

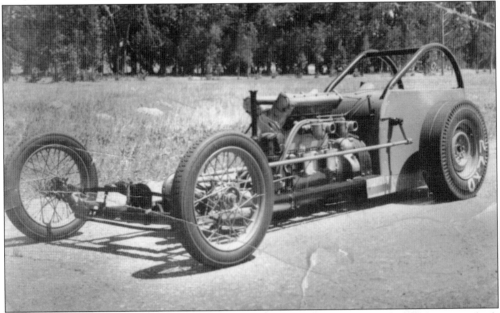

Veteran hot rod builder Jack Larimore of Ventura built this unusual Miller-powered dragster, which set a track record for four-cylinder–powered cars on October 2, 1960, when it reached 108.43 miles per hour on the quarter mile. The Miller Company produced highly tuned, custom-made racing engines, similar to Offenhausers, which were used mostly in Indianapolis racers and sprint cars. (Courtesy of Ambrose Little.)

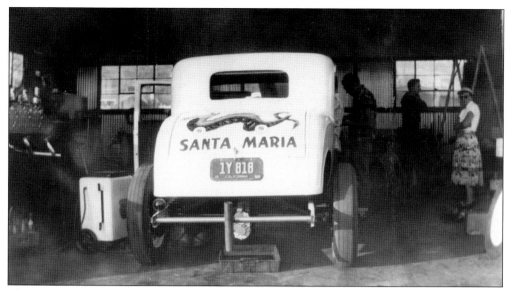

This 1932 five-window coupe belonged to Dale Latham and is shown being prepared for a trip to Bonneville in 1954, where it would attain 170 miles per hour. The location is Bob Joehnck's Garage on Chapala Street in Santa Barbara. Note the flathead on a stand at far left and the rather bored-looking young lady at far right. (Courtesy of Jerry Gaskill.)

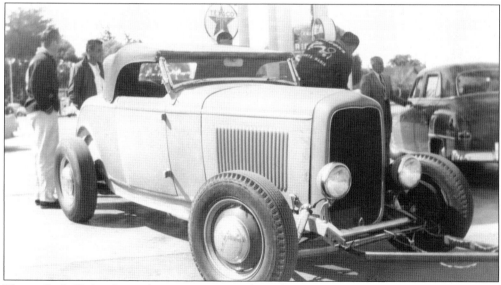

This is Gaskill's first hot rod, a 1932 Deuce roadster that he bought at age 14 and kept for many years. It is shown here on a trip with the Dragons to Salinas Drag Strip. The Dragons' bright red club coats were the football type, and on the back was the club logo, featuring a green-and-yellow dragon on wheels. (Courtesy of Jerry Gaskill.)

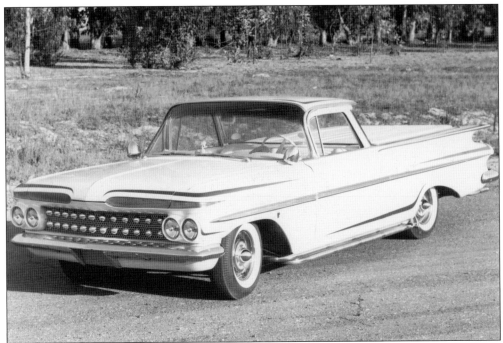

Famous customizer George Barris built these two street rods for Santa Maria local Jim Seaton. Seaton approached Jerry Gaskill, wanting a pair of customs, and Gaskill went to Barris for this result. The two cars drew large crowds when they appeared at local meets. Both Chevrolets—one a 1955 two-door sedan and the other a 1959 El Camino—were painted in matching white pearl with metallic copper trim schemes. (Courtesy of Jerry Gaskill.)

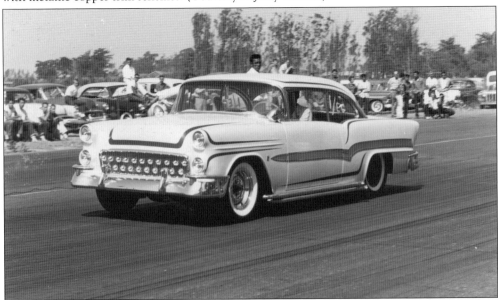

Carrying on the matching theme, the cars have each been equipped with lake pipes, twin spotlights, and the same grill treatment. The chrome "bullets" on the grill screens were fashioned from off-the-shelf kitchen doorknobs. The sedan still exists in a Midwestern collection, but the El Camino has become lost to time. (Courtesy of Jerry Gaskill.)

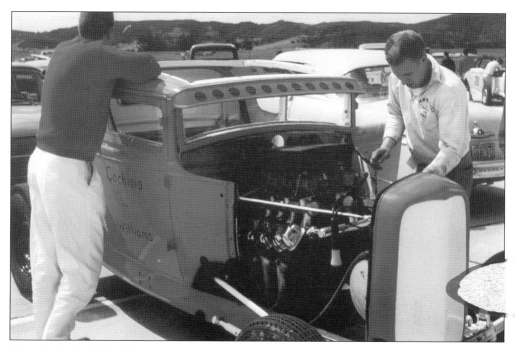

Tony Cochiolo (left), of the Santa Maria Dragons, and Jerry Williams, of the Ventura Kustomeers—co-owners of this DeSoto-powered 1931 Ford coupe—are seen preparing for a race at San Luis Obispo in 1959. They also ran this car at Bonneville Salt Flats. It was painted in a bright red-orange color known back then as "competition orange." (Courtesy of Jerry Williams.)

A legendary event in Central Coast drag-racing folklore was the day Ron Williams raced Dave Marquez in 1954. The friendly rivals, both from Ventura County, were just leaving the line after the flag dropped when the engine in Marquez's No. 880 cut out. Williams, in No. 159, was halfway down the track by the time he noticed Marquez's problem. Although technically the winner, Williams pulled his drag racer around in a U-turn and returned to the starting line in a display of good sportsmanship. The race was restaged, with Williams finishing as the winner. (Courtesy of Jerry Williams.)

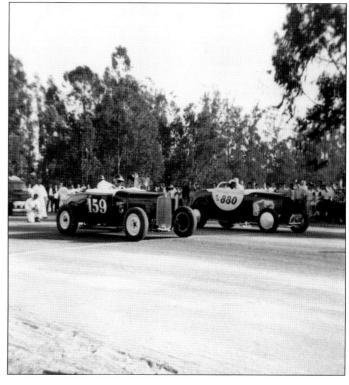

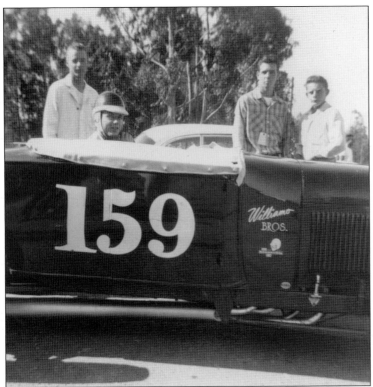

Pioneer hot-rodder Ron Williams of Ventura is seen here at Santa Maria in his maroon 1929 Model A roadster. Ron, a member of the Whistlers car club, was famous for a record-setting run at Bonneville in this car. Standing to Ron's right in the checked flannel shirt is another notable hot-rodder, Jim Harris, a member of the Kustomeers and later the Motor Monarchs. (Courtesy of Jerry Williams.)

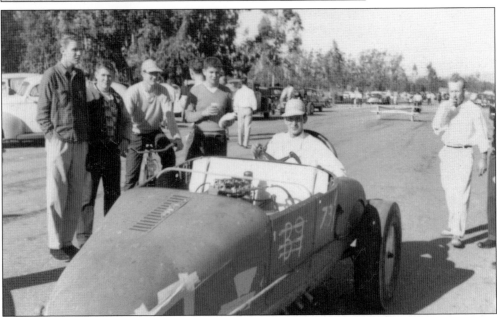

Dave Marquez of Santa Paula was National Hot Rod Association Class B top eliminator in 1955 as well as a member of the famous Motor Monarchs of Ventura. He is pictured in the Monarchs' club car, the 440 Junior. The little Model T–based dragster would soon be rebuilt by Howard Clarkson of the Motor Monarchs, who would become top eliminator in it in the 1956 Nationals. (Courtesy of Howard Clarkson.)

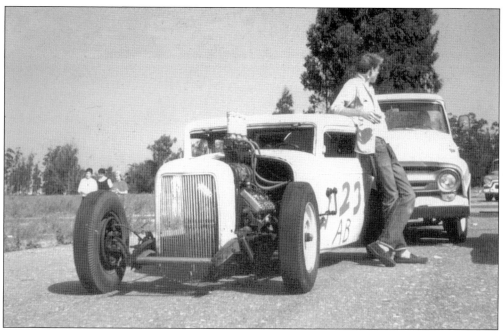

Looking cool as he leans against Tom Swiggins's 1932 Victoria is Greg Carlson of the Grave Gamblers car club. Swiggins raced the yellow Ford for the Grave Gamblers and powered it with a blown flathead, as seen here at Santa Maria. Note the 16-ounce Budweiser beer cans used as intake stacks for the triple Stromberg carburetor setup. (Courtesy of Jack Chard.)

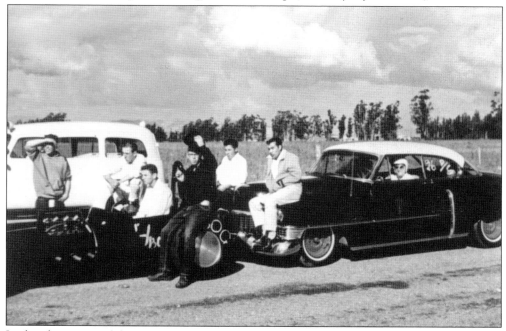

In this shot, some of the Dusters await their turns at the Santa Maria starting line while parked next to an ambulance. Jack Chard sits in the cockpit of his black dragster, and behind him is his friend and fellow Duster Bruce McGee. Although McGee is racing the Cadillac as a stocker, the car actually belongs to Chard. (Courtesy of Jack Chard.)

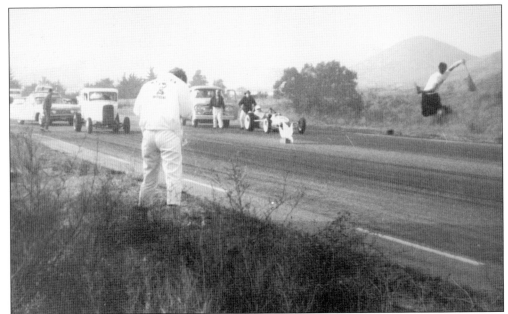

Jerry Gaskill also ran a strip 25 miles to the north in San Luis Obispo in conjunction with his operation at Santa Maria, forming the San Luis Obispo County Timing Association in 1955. Racing was done on the main runway of San Luis Obispo Airport. The flagman at San Luis Obispo was local law enforcement officer Bill Malman. Jack Mendenhall's 1932 coupe is at left. (Courtesy of Mark Mendenhall.)

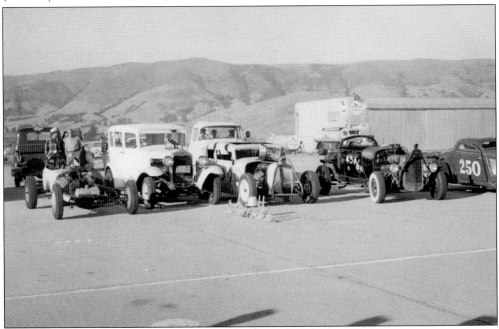

This formidable lineup of drag racers was taken at Jerry Gaskill's San Luis Obispo drag strip. From left to right are an early "rail" dragster, Jay Roach's 1931 Model A sedan, a chopped Model A Tudor, a 1929 roadster with a Deuce grill shell, and a radically chopped 1934 Ford Coupe. Note that each is equipped with a blower. (Courtesy of Hunter Self and Betty Roach.)

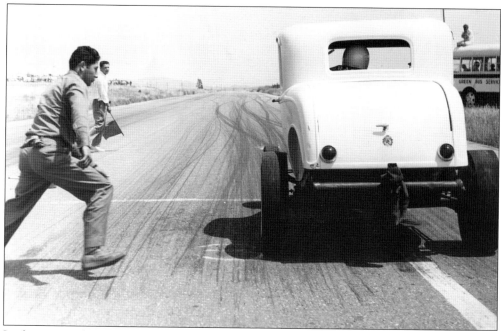

In this action shot, pit crew chief Marshall Solis rushes out to give Jack Mendenhall some last-minute instructions as Don Doeckle prepares to start the race at San Luis Obispo. Mendenhall, a member of the Bonneville 200 MPH Club, would later take this coupe up to 151 miles per hour on the salt flats. (Courtesy of Mark Mendenhall.)

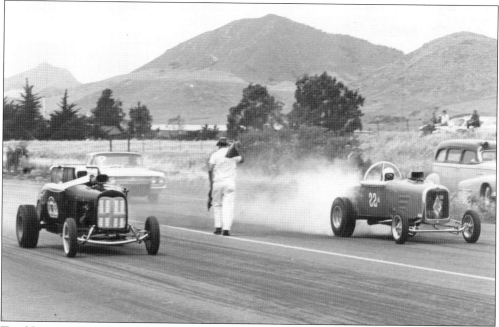

Two blown 1929 roadsters leave the starting line at San Luis Obispo in this image. At left is strip owner Jerry Gaskill, and at right is famous drag racer Tony Nancy. Gaskill's dragster was powered by Oldsmobile, while Nancy had a Buick Nailhead in his. At far right is the 1942 Buick ambulance that Gaskill kept on-site when the strips were operating. (Courtesy of Jerry Gaskill.)

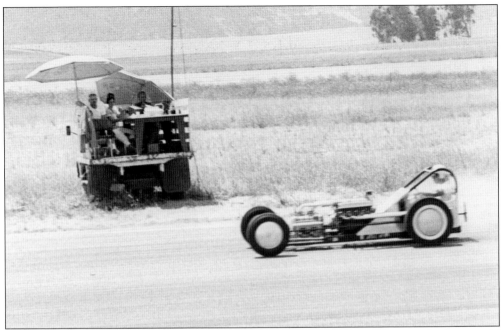

Since races at San Luis Obispo were actually held on an active runway for aircraft, there could be no permanent drag strip structures like bleachers or a timing tower. When an airplane did approach, a flag was waved, and everyone got out of the way. Minutes after this image was taken, the pole holding the PA system cable at right collapsed on the truck bed serving as the timing tower and struck Jerry Gaskill on the head, knocking him out. (Courtesy of Jerry Gaskill.)

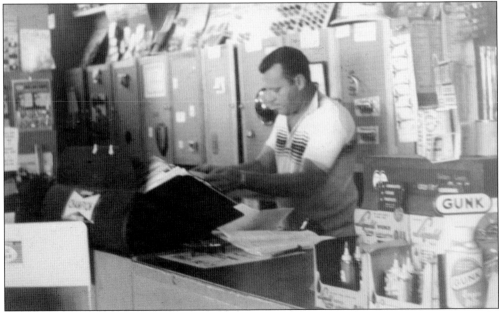

Jack and Jerry's Auto Supply, located at 565 Higuera Street in San Luis Obispo was owned by Jerry Gaskill and his partner Jack Hathaway, who is pictured behind the counter. The business, in operation from 1952 to 1961, was a well-known speed shop and was highly visible in the local hot rod community, competing at drag races with its own 1929 roadster. (Courtesy of Jerry Gaskill.)

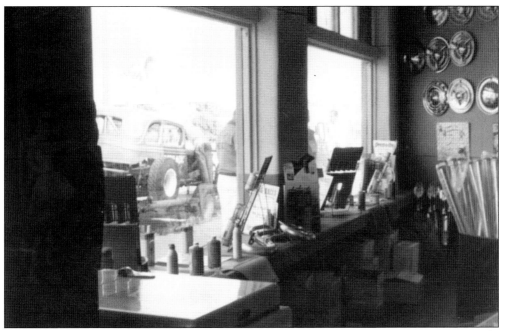

This is an interesting view from the other side of the counter. Various automotive products are on display in the windows, and an assortment of spinner hubcaps adorns the walls. Outside on Higuera Street, a channeled Ford Tudor sits on a trailer waiting to be towed to one of the local tracks as someone works on the engine. (Courtesy of Jerry Gaskill.)

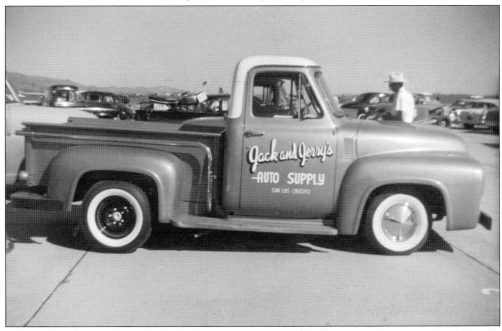

Jack and Jerry's used this 1954 Ford pickup as a tow/push truck. Painted in the store colors of purple and white, the truck was good for advertising the business, too. The long, chrome exhaust pipe seen passing over the rear fender along the pickup bed was an aftermarket lake pipe extension for trucks sold by the store. (Courtesy of Jerry Gaskill.)

Hot rod club activity continued on the Central Coast into the late 1960s as evidenced by this image of the Santa Barbara Oldies But Goodies car club taken at the 1968 Roadster Roundup in Pismo Beach, California. The group pictured here is in Lee Hammock's 1929 Ford Model A pickup, parked off of Pomeroy Street. (Courtesy of Lee Hammock.)

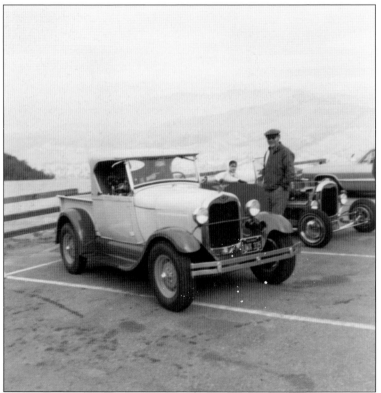

Here is another shot of Lee Hammock's roadster pickup, seen at a highway rest stop somewhere on the Central Coast. Parked behind him is a 1929 Ford Model A roadster hot rod belonging to Jack Chard. (Courtesy of Lee Hammock.)

Seven

ON THE ROAD

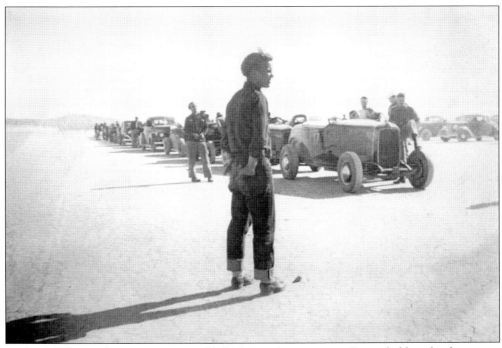

In the days before drag strips were established, "acceleration meets" were held in the desert east of the coast at El Mirage Dry Lake, attracting hot-rodders from all over California, including Santa Barbara County. Here are some images from the albums of Lee Hammock and Jack Chard showing some of the early postwar activities at El Mirage, as well as some from later on, when the action moved to the Bonneville Salt Flats in Utah. (Courtesy of Jack Chard.)

Santa Barbara residents Fielding Lewis (left) and Steve Tilford are seen enjoying a cooling beverage under the late-morning sun at El Mirage. They are seated on the fenders of Lee Hammock's 1937 Chevrolet while observing the timing trials. (Courtesy of Lee Hammock.)

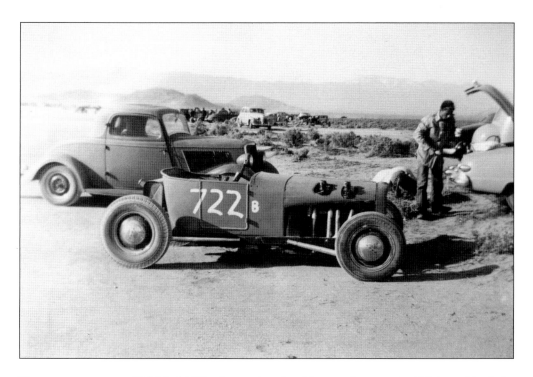

Here is an interesting 1927 Model T bucket roadster Lee Hammock snapped at El Mirage Dry Lake in 1950. Powered by a four-cylinder Model A engine equipped with two carburetors, this roadster was a typical lake racer. Note the 1934 Ford Coupe and new 1950 Studebaker Commander in the background. (Both, courtesy of Lee Hammock.)

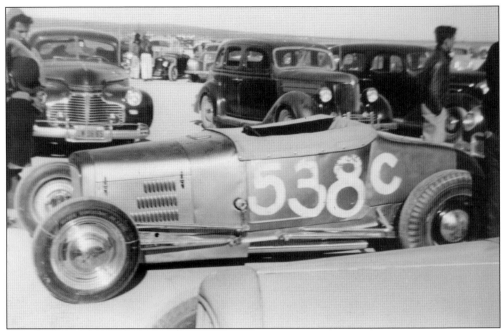

A hot rod seen regularly at El Mirage was this 1927 T roadster belonging to Bill Lyons. Famous in its day for having appeared in *Hot Rod Magazine*, this well-finished gold beauty has lots of chrome and sported a 1932 grill shell. Also visible is a set of Kenmont brakes, an early disc-brake system designed in the late 1930s. (Courtesy of Lee Hammock.)

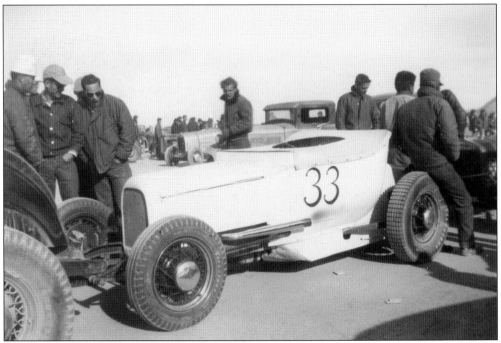

This group, clad in war-surplus clothing, is checking out a highly modified Model T roadster on a cold, clear morning at El Mirage in 1947. That is an Essex radiator shell up front on this lake racer car; note the homemade cross-tread lake tires on the rear. (Courtesy of Lee Hammock.)

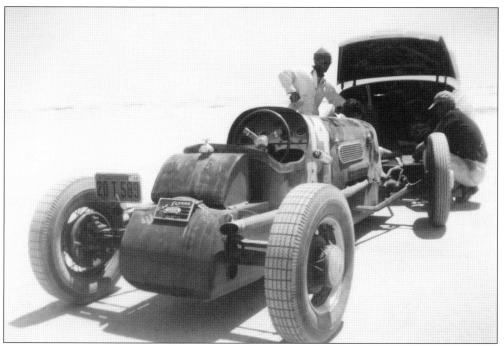

Here is a neat little sprint car that saw double duty as a lake racer at El Mirage sometime in the late 1940s. Probably built in the late 1930s, this solid-looking racer appears especially well constructed. The club plaque on the back reads, "Con Flyers, Santa Monica." (Courtesy of Lee Hammock.)

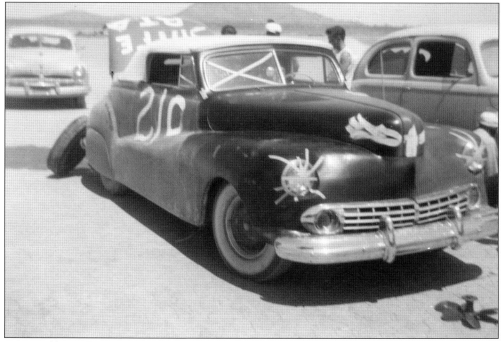

One could see almost anything competing in timing runs at El Mirage, including customs. This black-and-primer 1947 Mercury has an interesting front grill treatment, and the headlights and part of the windshield are well taped for safety. (Courtesy of Lee Hammock.)

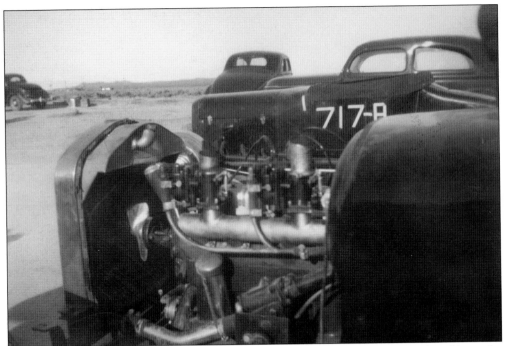

In this view looking out across the lake bed at El Mirage, the engine in the rod visible in the foreground is a Ford four-cylinder with a four-port Riley Head. Behind that is a V-8–powered 1927 Model T roadster with a 1932 grill shell. (Courtesy of Lee Hammock.)

This custom looks like it might have started life as a 1947 Mercury. It has been nosed, and its headlights, frenched, and that is a Cadillac grill up front. A Carson top and a pair of spotlights have also been added. Note how the windshield and headlights have been taped to prevent shattering in the event of a rock strike. (Courtesy of Lee Hammock.)

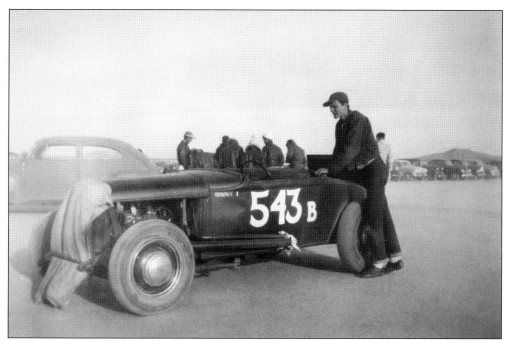

This shot captures the atmosphere of the early-morning meets at El Mirage well. The owner of this 1931 Ford roadster has wrapped the rod's radiator with a blanket to help keep it warm in the chilly air. The exhaust pipes coming out of the flathead V-8 have been plugged to keep out the morning dew. (Courtesy of Lee Hammock.)

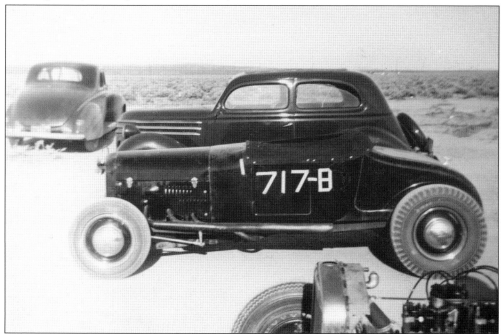

This 1927 Model T roadster is seen sitting in the staging area at El Mirage around 1947. From the triple-header exhaust coming out of the side panel, it looks like it is powered by a flathead V-8. In the background is a 1935 Ford Tudor sedan. (Courtesy of Lee Hammock.)

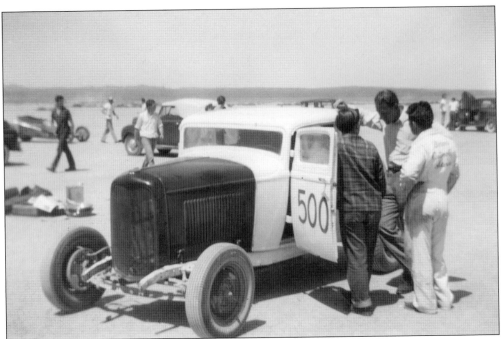

This 1932 Ford coupe was owned and driven by none other than well-known hot-rodder Lou Baney, cofounder of Saugus Drag Strip. The black-and-white Deuce coupe looks like it has been chopped about four inches. (Courtesy of Lee Hammock.)

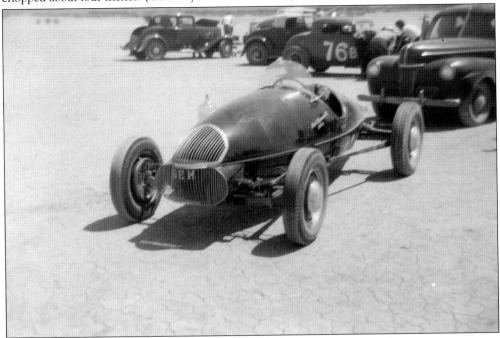

Tank racers, made from war-surplus aviation fuel tanks, were popular platforms for timing runs at El Mirage. This one is powered by a small, lightweight Crosley four-cylinder APU (auxiliary power unit) engine, another war surplus item. Note the homemade wire grill. (Courtesy of Lee Hammock.)

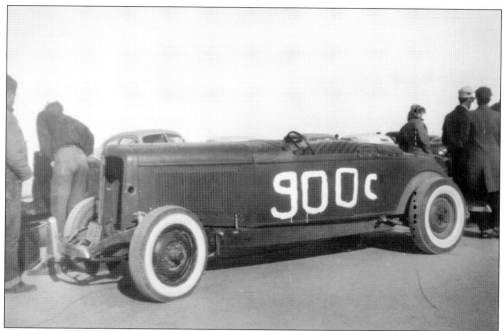

While the scene at El Mirage was dominated by Ford products, other makes did show up. A particular rarity in 1947 was this big V-16–powered 1932 Marmon roadster. Marmons had the reputation of being fast and powerful cars. A survivor of the wartime scrap-metal drives, this one may have been owned by Howard Johanssen of Howard's Cams. (Courtesy of Lee Hammock.)

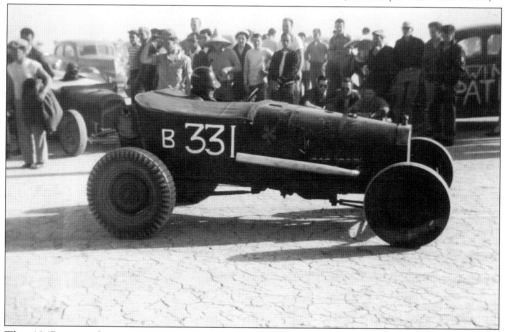

This 1947 image shows a 1927 T-bucket lake racer ready to start a timing run. Note the big lake tires on the rear and the way the radiator shell has been moved behind the front suspension. The sedan visible in the right background is a Southern California Timing Association safety-patrol vehicle. (Courtesy of Lee Hammock.)

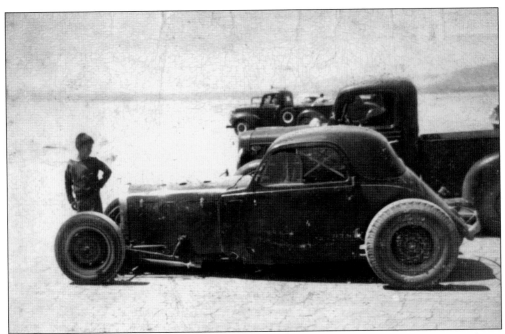

This 1947 photograph, which Lee Hammock carried around in his wallet for many years, shows the beginning of what later became a popular trend in drag racing: the use of small European cars—such as English Fords or, in this case, Italian Fiats—as the basis for lake racers or dragsters. (Courtesy of Lee Hammock.)

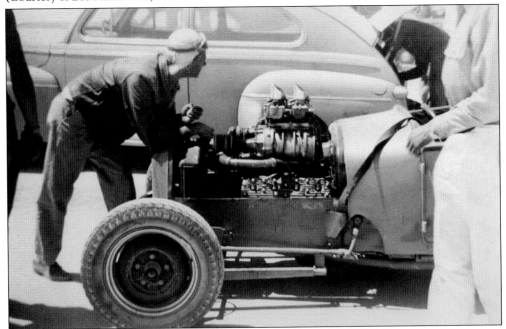

Some of the first blowers or superchargers were seen on the El Mirage lake bed in the very early days. The one mounted on this roadster's flathead engine looks like it has four Stromberg 97 carburetors sitting on top. Note the white, cloth, 1930s-style racing helmet on the fellow leaning on the radiator at left. (Courtesy of Lee Hammock.)

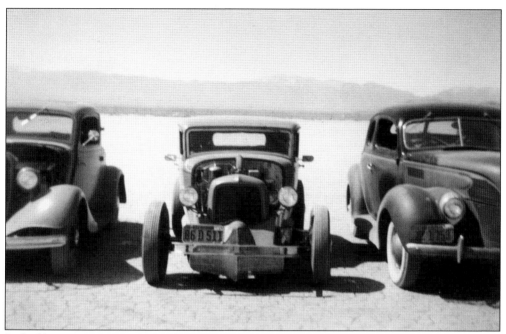

Parked between a 1934 coupe and a 1940 deluxe at El Mirage is this unusual Deuce coupe. Behind the nerf bar is a strange-looking dual-radiator grill setup combining a 1932 shell with a forward fairing that looks like it may be made up of Buick grill parts. This was all part of a belly pan that stretched underneath the car to the rear end. (Courtesy of Lee Hammock.)

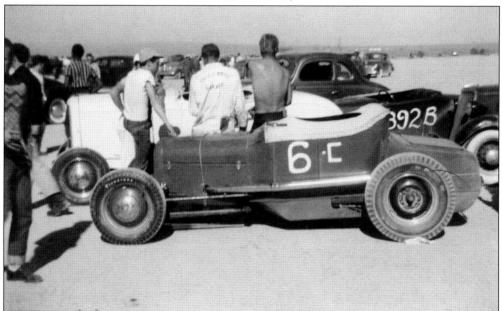

Phil Schindler's 1927 T-bucket has gained a new paint job and race number in this shot, which also shows the belly pan to good advantage. Traveling along the rough lake bed at 100 miles per hour, the tires could kick up quite a lot of dust and debris into the cockpit. This plus the fact that these old racers rode rather low made the protection a belly pan offered pretty attractive. (Courtesy of Lee Hammock.)

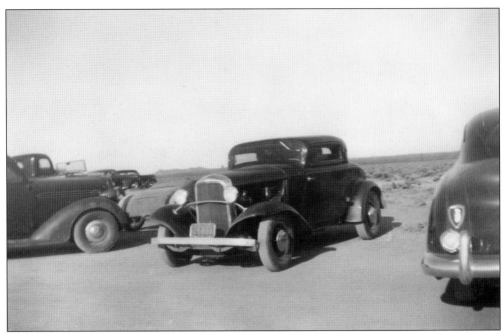

This sharp, full-fendered Deuce coupe was photographed by Lee Hammock sometime in the late 1940s at El Mirage. The black beauty looks like it has about a four-inch chop, and check out the very cool chrome-plated grill shell and smaller headlamps. (Courtesy of Lee Hammock.)

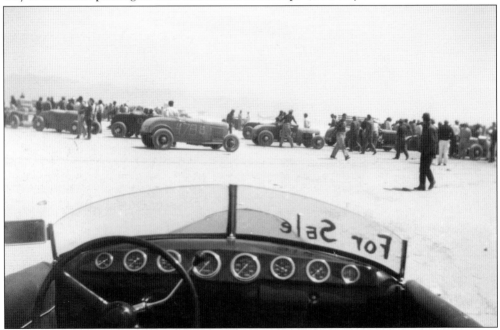

This is a great view of the pit area at El Mirage as seen from atop a 1929 Ford roadster. With all the action going on in the background, it would be easy to ignore this well-appointed hot rod. Beneath the homemade custom windshield, the dashboard displays a full array of Stewart-Warner gauges, very expensive in their day. Also, note the 1940 Ford steering wheel and column shift. (Courtesy of Lee Hammock.)

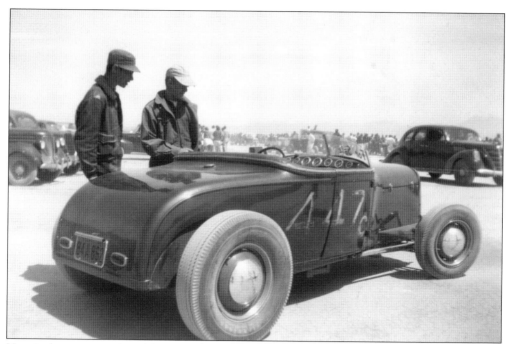

Here is the same car viewed from another angle. This very well-finished Deuce roadster may have been built by Jack Caloric, a well-known Los Angeles hot rod builder. He has installed Chevrolet taillight lenses on the decked rear end. (Courtesy of Lee Hammock.)

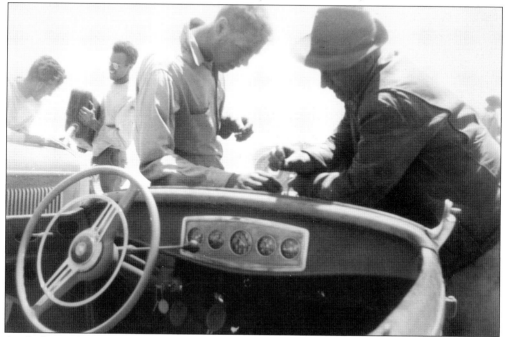

As the hot rod usually reflected the personality and budget of the owner, so did the rod's interior. This 1932 Ford roadster is equipped with a complete Stewart-Warner gauge set, including a chrome metal dash-panel insert. Other popular alternatives were Auburn dashboards and even speedboat dashes. Note the Mercury steering wheel and column shift. (Courtesy of Lee Hammock.)

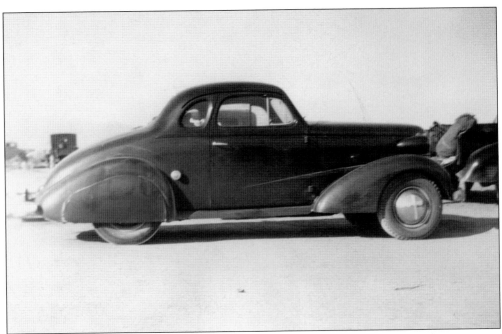

Not all hot-rodders drove Fords. This is Lee Hammock's black 1937 Chevrolet coupe. These cars were popular for their sleek Art Deco styling. And, equipped with a strong, reliable in-line six-cylinder overhead engine, they could move too. Lee tuned his engine with a hot camshaft, ported head, and dual-carburetor intake manifold. Note the fender skirts. (Courtesy of Lee Hammock.)

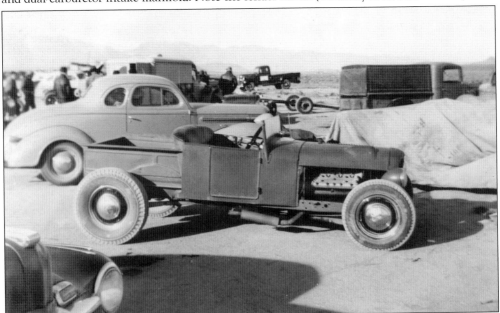

This and the following image from El Mirage in 1947 show a very interesting hot rod made of a conglomeration of different parts. The cockpit came from a 1926 or 1927 Ford Phaeton. Note how the body has been cut in a straight line behind the door. The Model A pickup bed has been moved forward on the frame, as evidenced by the location of the wheel arch. (Courtesy of Lee Hammock.)

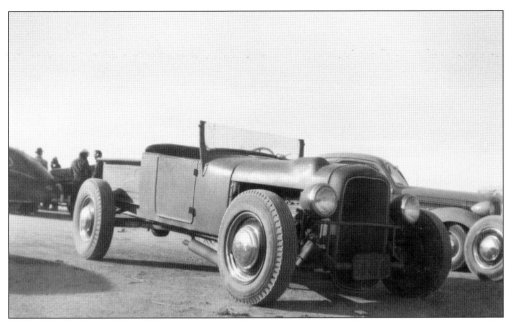

At the front, the Deuce radiator shell has had the bottom trimmed to drop down over the 1929 frame for a low, cooler look. The headlights, possibly from a 1936 Ford, rest on a simple bar. That bulge on the hood is most likely covering the generator that is sitting atop an early 21-stud flathead V-8. This is the kind of hot rod that was driven, rather than towed, to the meet. (Courtesy of Lee Hammock.)

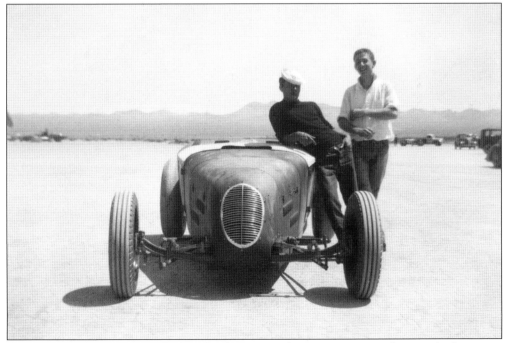

Wes Jacobs of Santa Barbara (left) and Bob Burnett of Montecito pose with a nice-looking rear-engined lake racer at El Mirage around 1948. This car went through many different modifications throughout its career. (Courtesy of Lee Hammock.)

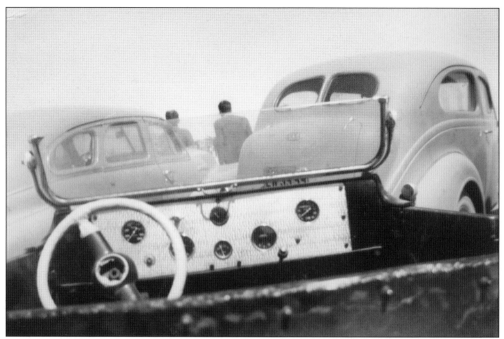

Here is another interesting dashboard treatment. The owner of this late-1920s Dodge hot rod has taken a rectangular piece of fine veneer and mounted a full set of aftermarket gauges on it. The steering wheel looks like it came from a 1940 Ford Deluxe. (Courtesy of Lee Hammock.)

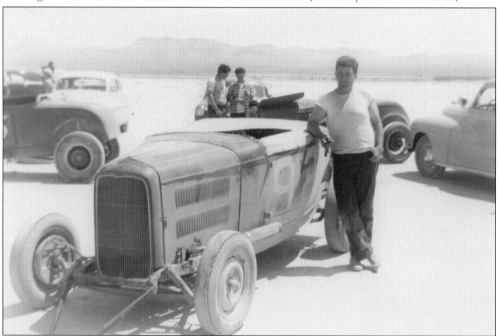

Stoddard Hensling of Santa Barbara poses at El Mirage Dry Lake with his primer-gray 1932 Ford Deuce roadster. Note the tow bar and the tube shocks on the front end. Tube shocks were beginning to replace the older lever-action or friction shocks by the late 1940s. (Courtesy of Lee Hammock.)

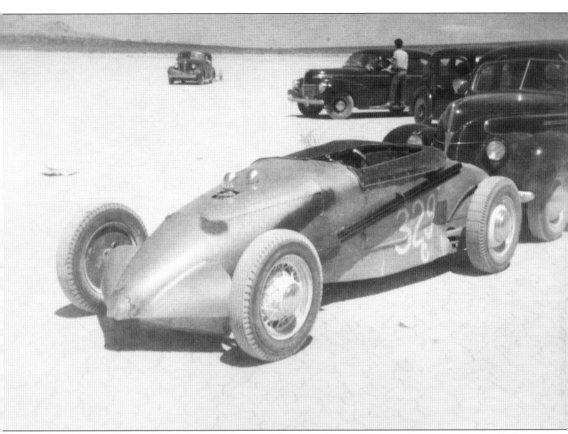

Here is a good example of an early attempt at aerodynamic design, or streamlining, as it was called. This 1927 roadster has had the front axles faired over and a belly pan installed. The color is gold metallic, with some patchwork visible on the extreme nose. The cross-treads on the rear tires were cut by hand with a hot iron for better traction on the lake bed. (Courtesy of Lee Hammock.)

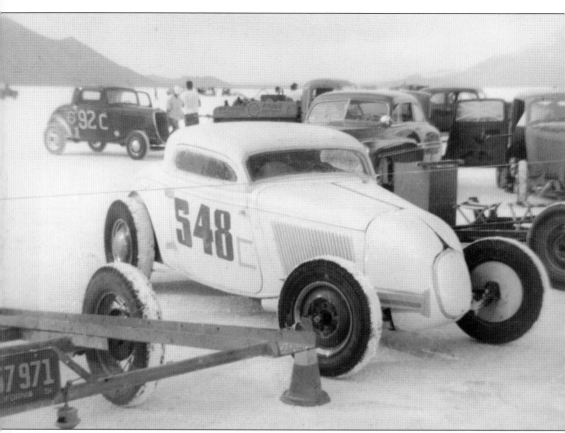

Because El Mirage was too small for the kind of speeds that racers were beginning to achieve, the action moved to the Bonneville Salt Flats in Utah by 1951. Hot-rodders from all over the country began meeting there, and the guys from the Central Coast were no exception. Lee Hammock and Rip Erickson were there early on with this Wayne-GMC–powered 1934 Ford coupe. Erickson was able to get it up to 142 miles per hour on its speed run, but what is really interesting about this particular hot rod is its history. Built in Carpinteria by Ollie Olivas, it moved to Ventura for a while and was then bought by Jack Quinton. Quinton replaced the GMC engine with a flathead and sold it to hot rod writer Alex Xydias of Los Angeles. Under Xydias's ownership, the car acquired a white paint job with red scallops and became one of the world-famous "SoCal Speed Shop" specials. (Courtesy of Lee Hammock.)

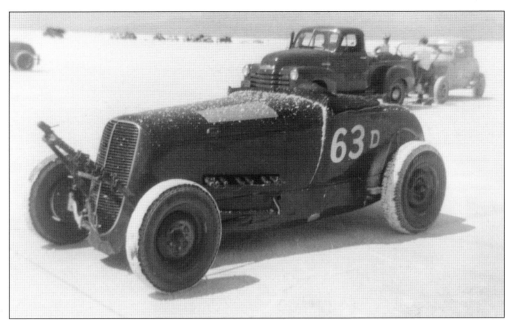

While at Bonneville, Lee Hammock snapped a picture of this 1929 Ford roadster. The grill shell might be from a mid-1930s Dodge or Chrysler, but what makes this one really unusual is the V-16 Marmon engine under the hood. Note the eight exhaust stacks coming out of one side. The tires are caked with salt from the lake bed, and there is a liberal sprinkling of it on the car's body as well. (Courtesy of Lee Hammock.)

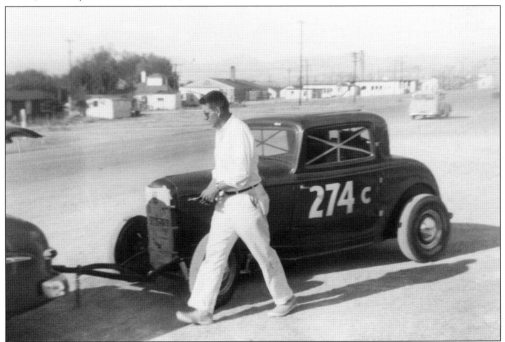

Another member of the Santa Barbara contingent at the salt flats was Jack Quinton, seen here with his hot rod in downtown Bonneville. Jack towed the metallic gold 1932 Ford coupe to Utah using his Mercury, visible on the left. (Courtesy of Lee Hammock.)

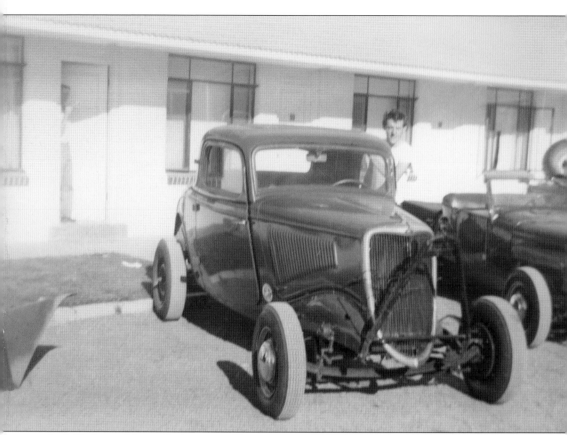

Jack Slickton of Santa Barbara towed his 1934 Ford coupe to Bonneville. The Model T roadster at right was driven all the way to Utah by a Santa Barbara hot-rodder remembered only by his nickname, "Just Plain Bill." That is a Pontiac grill shell on the Model T. (Courtesy of Lee Hammock.)

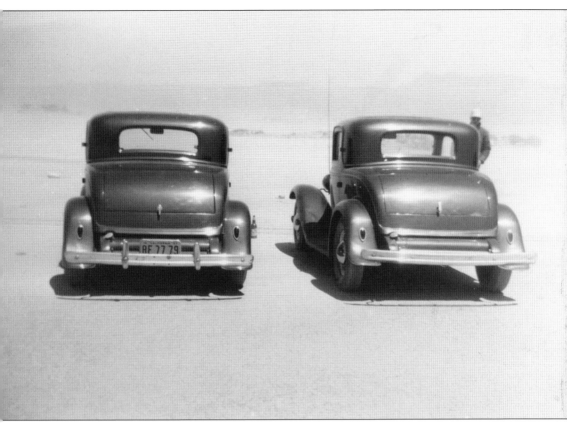

A rear view of two virtually identical Deuce coupes seems like an appropriate way to end this pictorial history of hot rodding in Santa Barbara County. The story of how a group of Central Coast hot rod enthusiasts moved into a pair of abandoned air bases and helped create a national sport has been told here through their images and memories. Although the venues for seeing motor sports have diminished since the golden days of the 1940s, 1950s, and 1960s, there are still places on the coast where one can go to the races. And, despite the fact that hot rodding is well over a half century old, there seem to be more and bigger car shows each year, drawing bigger and bigger crowds. Perhaps it will never die out. (Courtesy of Lee Hammock.)

DISCOVER THOUSANDS OF LOCAL HISTORY BOOKS
FEATURING MILLIONS OF VINTAGE IMAGES

Arcadia Publishing, the leading local history publisher in the United States, is committed to making history accessible and meaningful through publishing books that celebrate and preserve the heritage of America's people and places.

Find more books like this at
www.arcadiapublishing.com

Search for your hometown history, your old stomping grounds, and even your favorite sports team.

Consistent with our mission to preserve history on a local level, this book was printed in South Carolina on American-made paper and manufactured entirely in the United States. Products carrying the accredited Forest Stewardship Council (FSC) label are printed on 100 percent FSC-certified paper.

MADE IN THE
USA